POSTCARD HISTORY SERIES

Milford

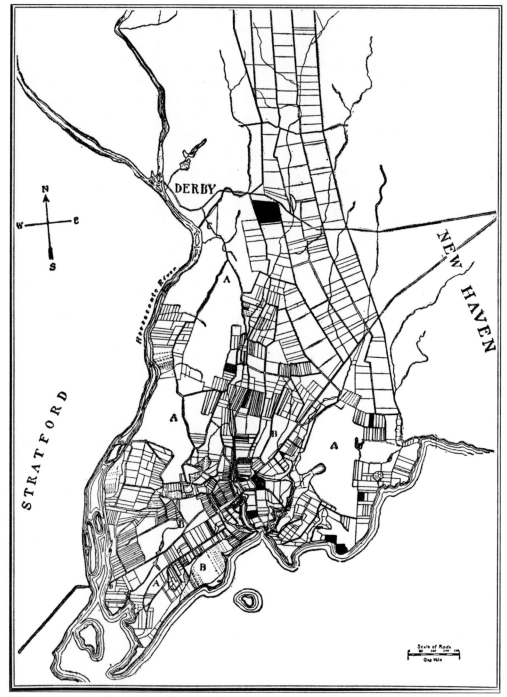

MILFORD MAP. This is an early map of Milford showing the borders and shoreline.

POSTCARD HISTORY SERIES

Milford

Melville Hurd

ARCADIA

Published by Arcadia Publishing
Charleston SC, Chicago IL, Portsmouth NH, San Francisco CA

Printed in the United States of America

Library of Congress Catalog Card Number: 2005936484

For all general information contact Arcadia Publishing at:
Telephone 843-853-2070
Fax 843-853-0044
E-mail sales@arcadiapublishing.com
For customer service and orders:
Toll-Free 1-888-313-2665

Visit us on the Internet at http://www.arcadiapublishing.com

SACHEM'S ISLAND. This small piece of land behind the Memorial Tower is reputed to be the site where Ansantawae, chief of the Paugussets, set up his camp when visiting the early Milford settlers. The Fowler mill appears in the background behind the east end of Memorial Bridge.

CONTENTS

ACKNOWLEDGMENTS

About 15 years ago, my father, Melville E. Hurd Sr., donated many historical maps, documents, and postcards to the Milford Historical Society. The leftovers that he considered to not be of historical value were given to me. These postcards became the start of my collection, which later became my obsession. This book is dedicated to him, who lived in Milford for over 70 years and never lost his love for the basic values that are a part of the town.

I would like to thank Van and Mary Hendrickson for their encouragement, support, suggestions, and legwork to help make this book possible. They have become my eyes and ears for news and changes happening around Milford.

I would also like to give special thanks to my wife, Sherril Larsen Hurd, for putting up with my craziness when it comes to Milford postcards. She always has a good word to say when I put a newly acquired postcard in her face and say, "Isn't it great?"

INTRODUCTION

At the beginning of the 20th century, postcards were the latest craze and the perfect way to show everyone where you had been and what it looked like in a beach town like Milford. With 17 miles of beaches and a picturesque town center, Milford was the perfect place to get away and enjoy the cool summer breezes, explore the historic sites, and eat a "shore dinner."

Postcards were available everywhere downtown and at every beach shop, hotel, and business that catered to the needs of the beachgoers. Publishers from New York, New Haven, and other larger cities supplied pictures of every aspect of the beach activities and the town landmarks like Charles Island, where Captain Kidd reportedly hide his treasure, Fort Trumbull at the mouth of the harbor, and Memorial Bridge. Many small pharmacies, hotels, and grocery stores published their own postcards, focusing on local area highlights like the Island View and Sound View Hotels at the beach, Fecker's Pier at Walnut Beach, and views of beach streets lined with rental cottages.

The golden age of postcards ended with World War I because most of the quality postcards were printed in Germany. In this book, many of the nicer postcards were printed abroad; the inexpensive cards printed by local businesses were of inferior quality. I have tried to use as many real-photo postcards as possible in this book to ensure high resolution.

Most of the postcards used for this book were sent before 1920. Many were selected to show the cottages and buildings that did not survive due to fires and hurricanes, especially in the western beach areas. Redevelopment took place in part of Silver Beach and all of Myrtle Beach in the late 1960s. The downtown buildings and historic sites have survived for the most part, and if the reader walks the Milford Green and walks north on River Street, this book can be used as a guide. Stand where the photographer stood and see the town now as compared with a bygone era.

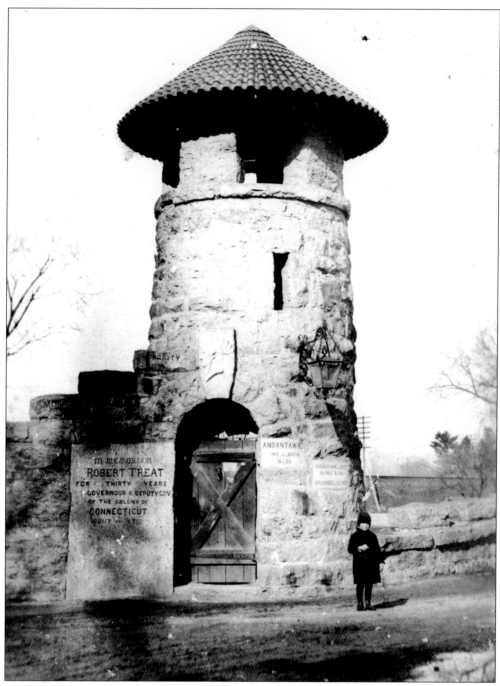

MEMORIAL TOWER. Built on the west end of Memorial Bridge, this tower honors Robert Treat, Milford's most famous founder. To the left of the tower is a carved inscription to Treat and his accomplishments. Above the oak door is a relief of Ansantawae, who was the chief of the Paugusset Indians at the time of the founding of Milford in 1639.

One

AROUND THE OLD TOWN

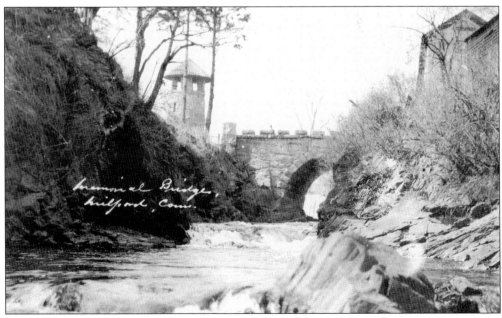

WEPAWAUG GORGE. Featured here is Memorial Bridge as seen from the gorge, showing the Memorial Tower, bridge arch, and waterfall as the Wepawaug River meets the harbor.

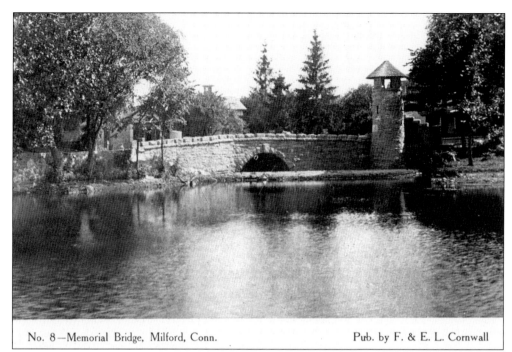

No. 8—Memorial Bridge, Milford, Conn. Pub. by F. & E. L. Cornwall

MEMORIAL BRIDGE. This bridge (above) was built in 1889 to celebrate Milford's 250th anniversary. Each of the 54 granite blocks that line the bridge commemorate a town founder, ending with the red roofed tower in honor of Robert Treat, who served as a state official and governor for 30 years. The postcard below looks west across the bridge toward the town green.

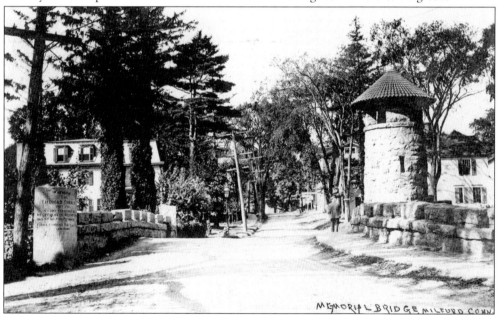

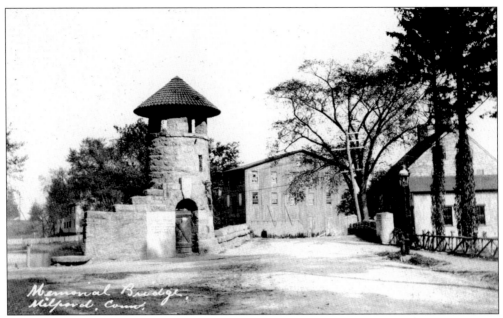

MEMORIAL BRIDGE AND FALLS. The image above is a view looking east across Memorial Bridge. The old Fowler grain mill and homestead can be seen in the distance. The original mill was built on this site in 1640, and the building in this postcard was demolished in 1914. Below are the bridge and waterfalls, looking up the Wepawaug River with the harbor to the photographer's back.

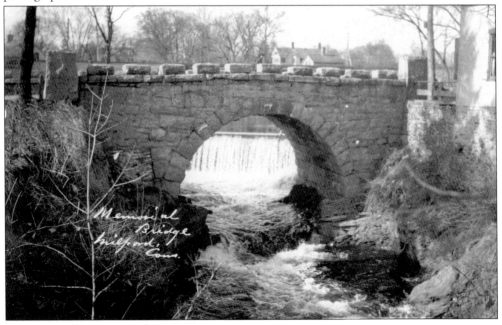

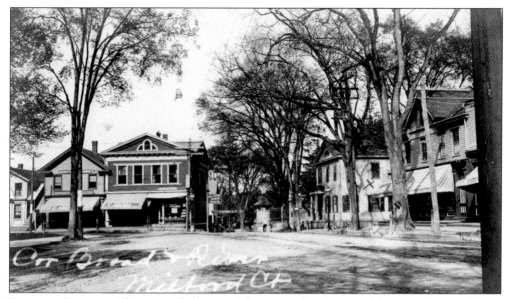

LIBRARY CORNER. The postcard above and the postcard at the top of the opposite page form a panoramic view of the junction of Broad and River Streets. The corner on the left was commonly known as library corner.

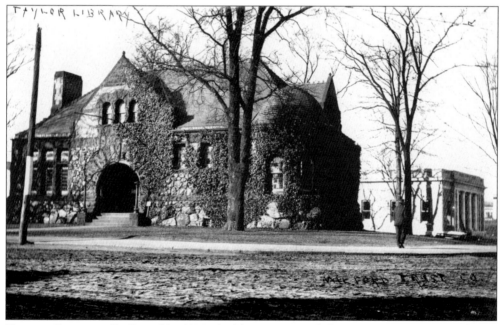

TAYLOR LIBRARY. Dedicated in 1895, the library was a gift from Henry Augustus Taylor on land provided by the town. The Milford Trust Company building is seen to the right.

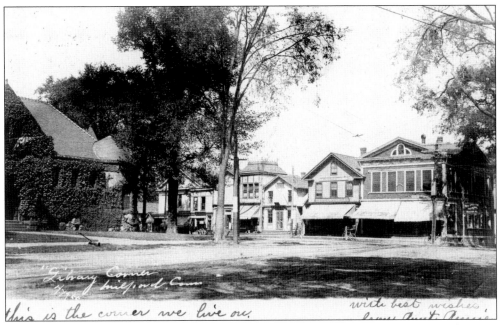

BROAD STREET. Looking east toward River Street, the Memorial Bridge tower can be seen. The picture was taken from the point of Broad Street where it splits to go around the green.

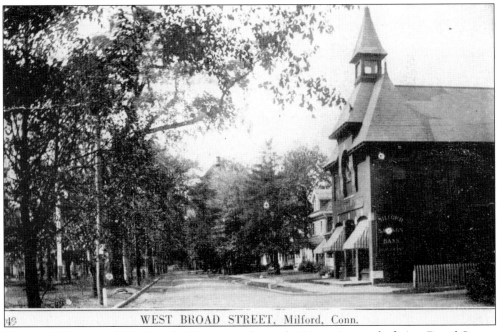

WEST BROAD STREET, Milford, Conn.

MASONIC TEMPLE. This view looking west shows the Masonic temple facing Broad Street. The temple was begun in 1878 and has had many businesses operate from the ground floor, including a meat market and the Milford Savings Bank.

13

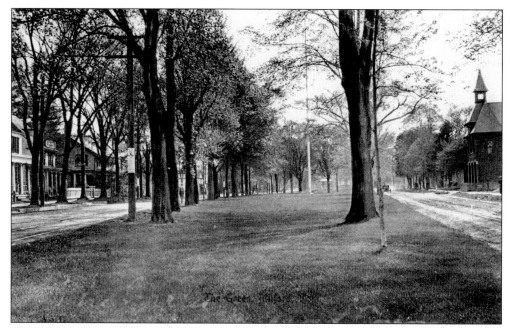

MILFORD GREEN. In this view looking west, one can see North Broad Street as well as South Broad Street forming the Milford Green.

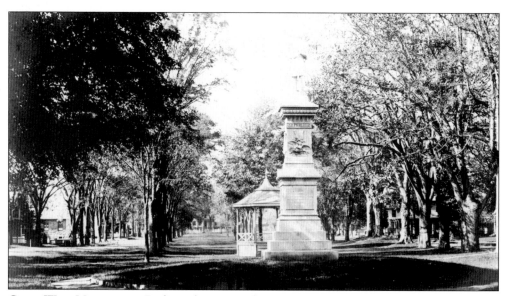

CIVIL WAR MEMORIAL. Dedicated in 1888, this memorial was created to honor the men of Milford who died in the war. It was built at a cost of $300 by the Milford Grand Army of the Republic chapter. The town bandstand is behind the monument.

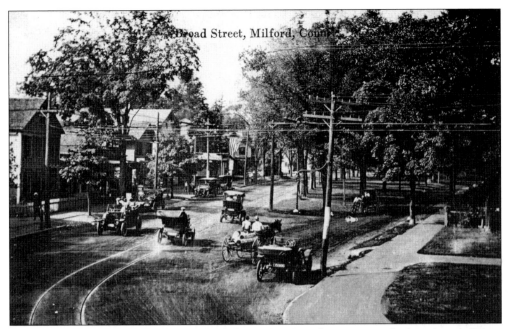

Broad Street, Milford, Conn.

MILFORD ANNIVERSARY. The postcard above is a view from an upstairs location on River Street; it shows the normal traffic at the east end of the green. Below one can see the same vantage point in 1914 during the celebration of the 275th anniversary of Milford.

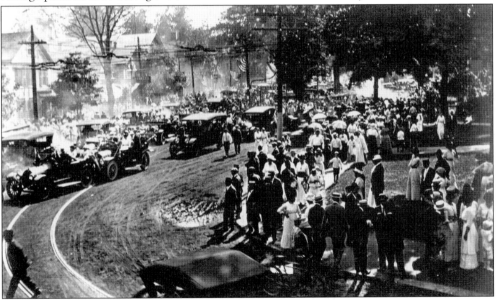

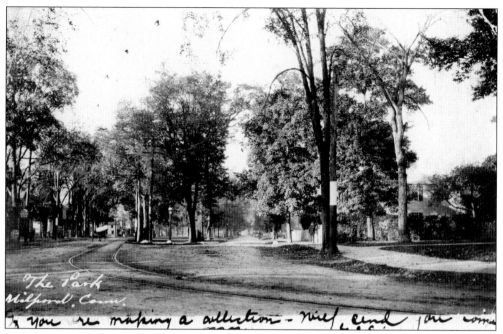

MILFORD GREEN WEST. This is a very early real-photo postcard looking west down both sides of the green. A horse-drawn wagon carries a load on South Broad Street.

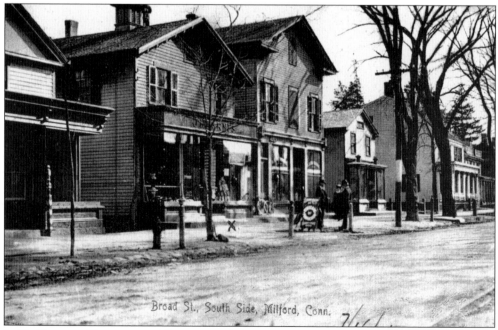

J. H. BARNES HARDWARE. This postcard shows a 1907 view of the J. H. Barnes hardware store, now Harrison's. The unpaved street is flanked by old cannons, which were used as hitching posts for horses.

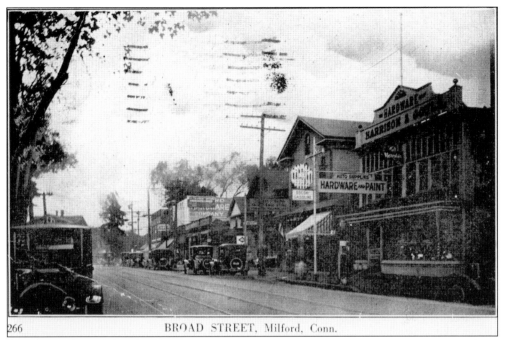

BROAD STREET, Milford, Conn.

266

SOUTH BROAD STREET. Looking toward River Street, this image was taken across from Harrison and Gould's hardware store.

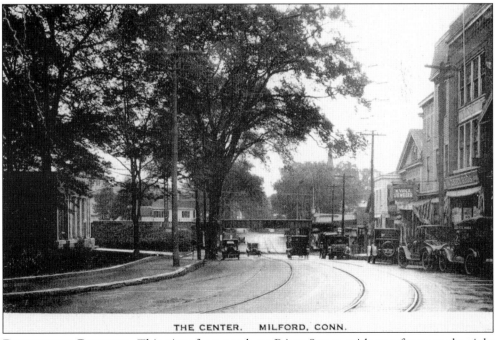

THE CENTER. MILFORD, CONN.

DOWNTOWN BUSINESS. This view faces north on River Street, with storefronts to the right and the Milford Trust building on the left. The bridge in the distance is the New Haven Railroad crossing.

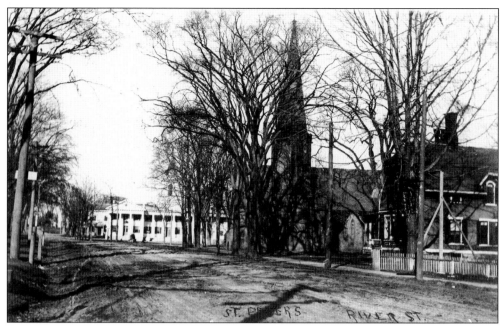

ST. PETER'S CHURCH. This postcard looks north on River Street toward the old town hall, with St. Peter's Episcopal Church on the left. The church was completed in 1851.

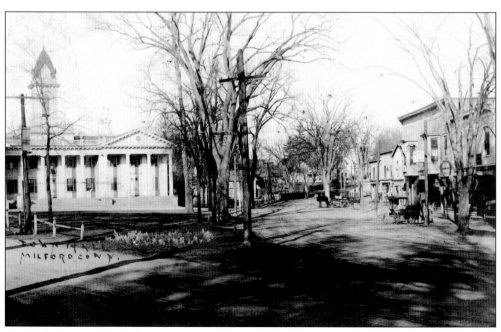

RIVER STREET. This real-photo postcard shows River Street as it divides at the town hall and connects to Cherry Street. A horse-drawn buggy has just crossed Jefferson Bridge.

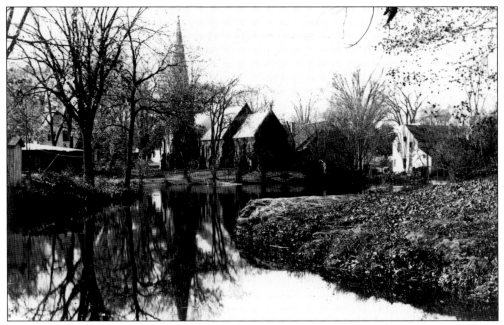

WEPAWAUG RIVER. This springtime view looks north on the Wepawaug River, showing the back of St. Peter's Episcopal Church.

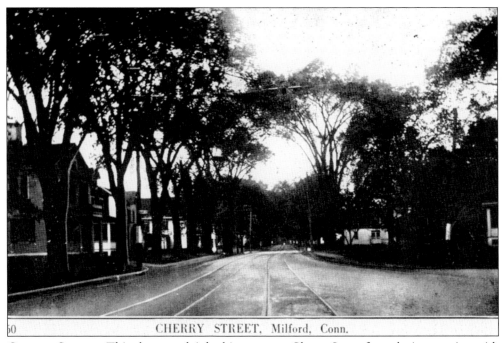

CHERRY STREET, Milford, Conn.

CHERRY STREET. This photograph is looking west on Cherry Street from the intersection with Gulf Street. Cherry Street is the connector for Milford center to the Boston Post Road.

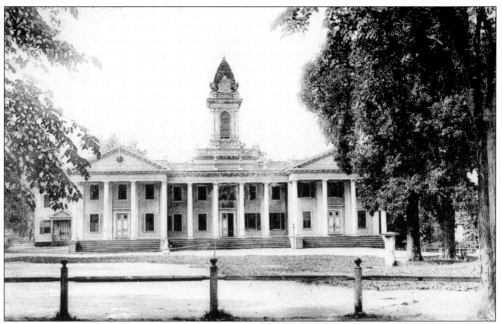

TOWN HALL. Above is the 1880 town hall. It was combined with the Baptist church on the right to form this building. It served as the town school as well as government offices. Below is a real-photo postcard of the town hall ablaze on the night of February 18, 1915.

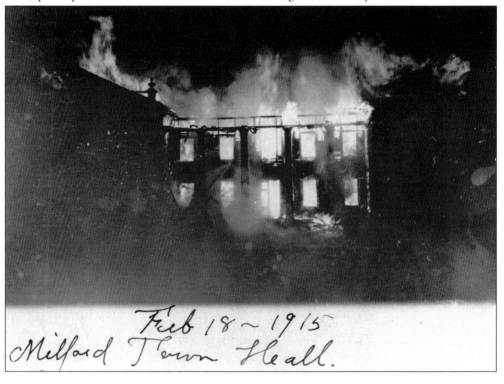

Feb 18 ~ 1915
Milford Town Hall.

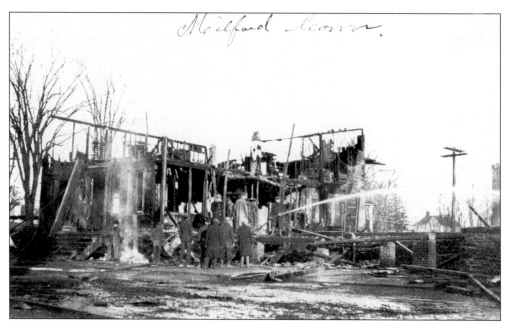

TOWN HALL FIRE. Above, firemen put out the last of the town hall fire on the morning of February 19, 1915. Citizens look over the devastated remains after the fire in the image below. The stone vault to the far right contained the town documents and, luckily, survived.

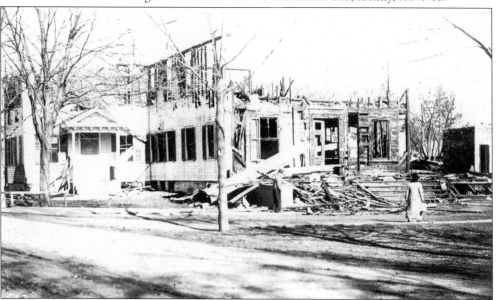

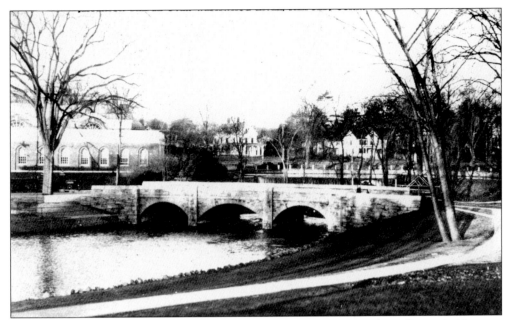

JEFFERSON BRIDGE. Originally a wooden structure built in 1803, the Jefferson Bridge was reinforced by steel to allow trolley traffic and later was rebuilt in stone as shown.

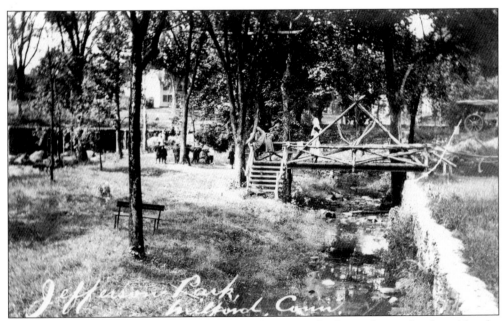

JEFFERSON PARK. Built on the site of the Dickinson mill, this park was developed by the Village Improvement Association about 1914. It is probably the most popular place in town for wedding pictures.

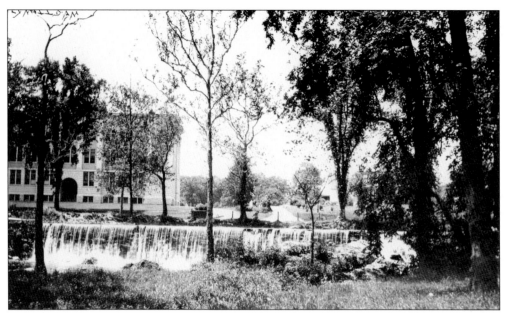

JEFFERSON PARK FALLS. The postcards on this page show Jefferson Park in summer and winter. Behind the Dickinson dam are the newly completed high school and the other residences that face the "Middle Pond."

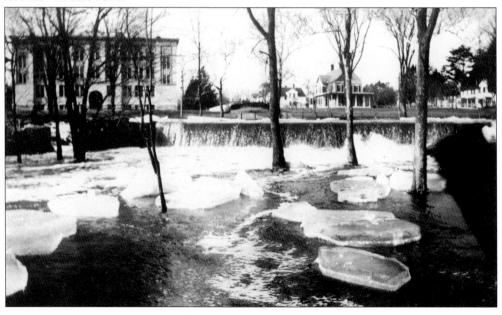

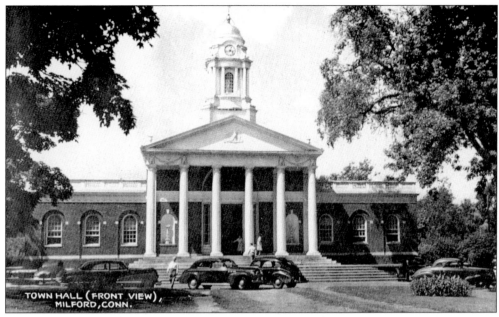

TOWN HALL (FRONT VIEW), MILFORD, CONN.

NEW TOWN HALL. Above one can see the new town hall, which was built to replace the old building that was destroyed by fire in 1915. The postcard below shows the back of the newly completed town hall across the pond. A construction building can be seen to the right of the building.

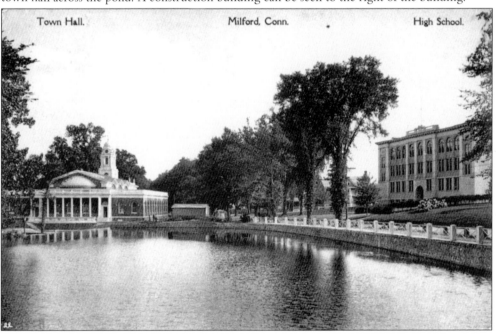

Town Hall. Milford, Conn. High School.

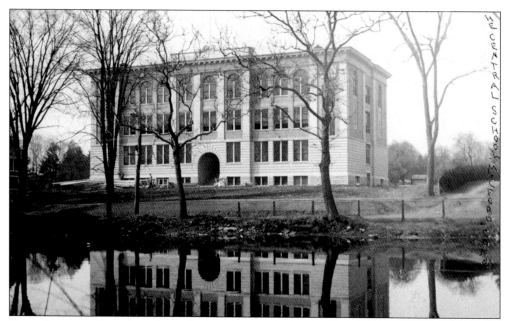

HIGH SCHOOL. The view above displays the new high school just before completion in 1916. It was built on the site of a house used to hide the regicides, the judges sought by the king for condemning his father to death during the Cromwell revolution in England.

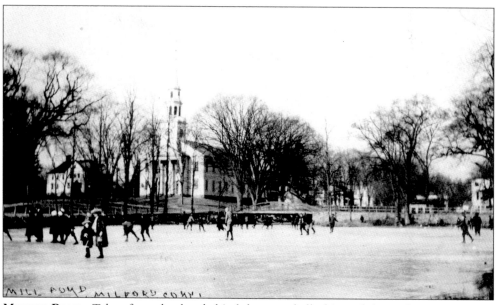

MIDDLE POND. Taken from the dam behind the town hall, this card shows skaters enjoying a day on the ice.

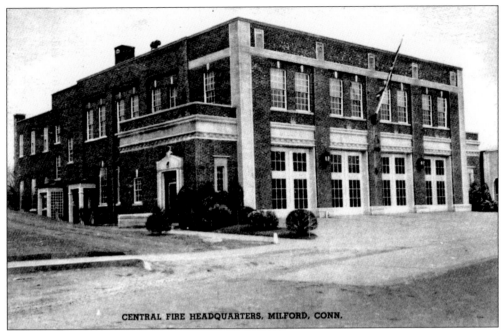

CENTRAL FIRE HEADQUARTERS, MILFORD, CONN.

ARTIC ENGINE COMPANY. Originally located on Factory Lane, the firehouse on New Haven Avenue is still in use today. Below, citizens are inspecting the new chemical engine truck bought for Artic No. 1.

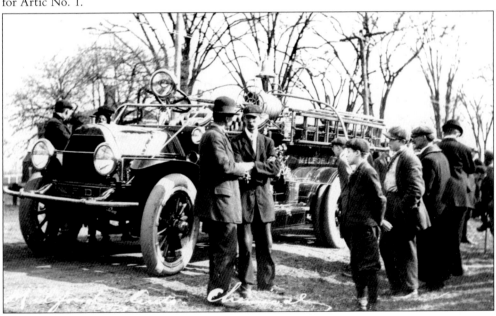

Two

CHURCHES AND
HISTORIC STRUCTURES

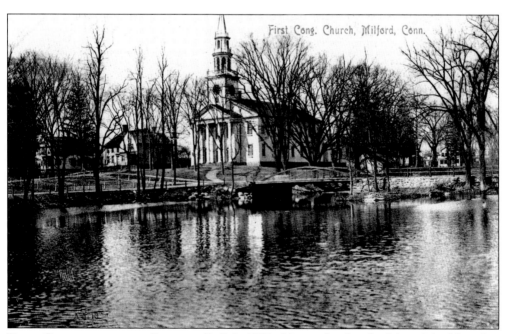

FIRST CONGREGATIONAL CHURCH. Built in 1823, this was the church of the original founders of Milford.

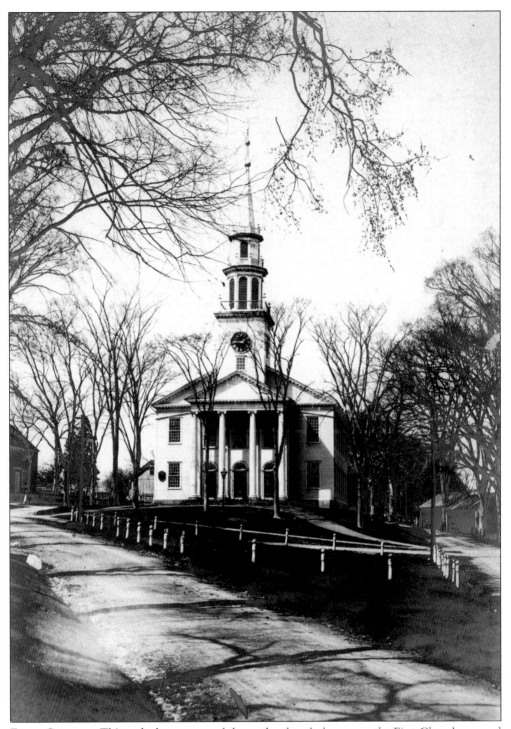

FIRST CHURCH. This real-photo postcard shows the church, known as the First Church, around 1910. It is now known as the First United Church of Christ (Congregational).

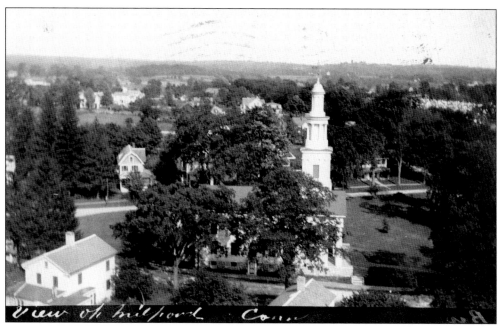

PLYMOUTH CHURCH. Due to a split over church doctrine, a second Congregational church was formed in 1741. Above one can see the Plymouth Church from the tower of the First Church. The church below is seen in 1915. This site is now occupied by the Plymouth building and is the Sunday school for the First Church.

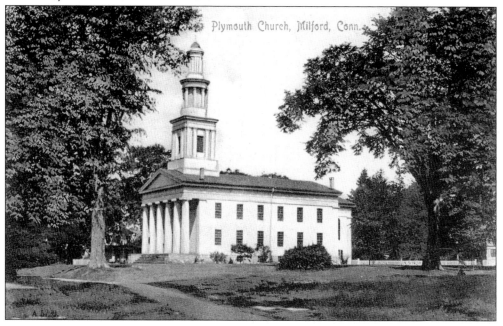

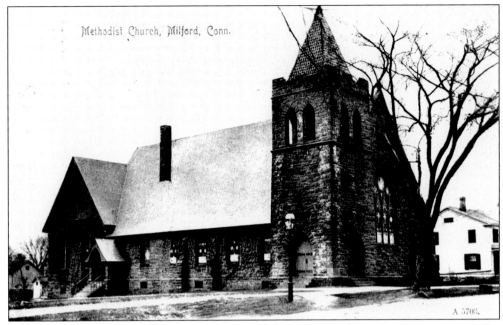

MARY TAYLOR METHODIST CHURCH. Located on Broad Street facing the green, Mary Taylor Methodist Church was dedicated in 1893.

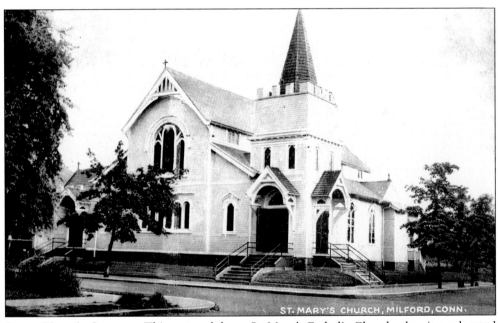

SAINT MARY'S CHURCH. This postcard shows St. Mary's Catholic Church when it was located on the corner of Gulf Street and New Haven Avenue.

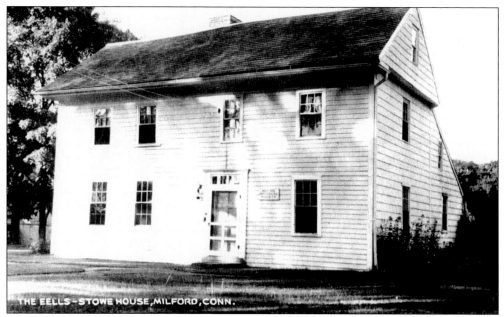

EELLS-STOWE HOUSE. The Eells-Stowe house, built about 1770, is an example of the Colonial saltbox style with an addition on the back. It is now owned by the Milford Historical Society.

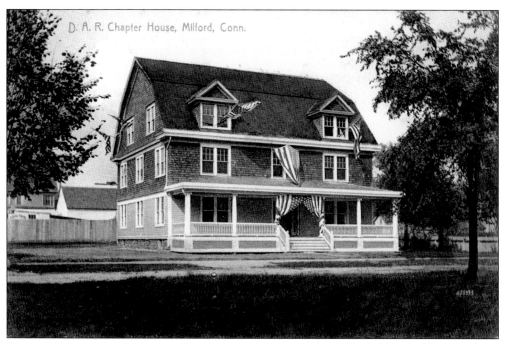

DAUGHTERS OF THE AMERICAN REVOLUTION HOUSE. The Milford chapter of the Daughters of the American Revolution formed in 1896 and built this house on Broad Street in 1907.

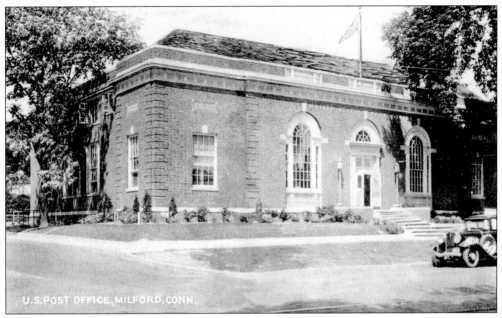

U.S. POST OFFICE. Moved from the corner of Daniel and River Streets, the post office shown here was built in 1932.

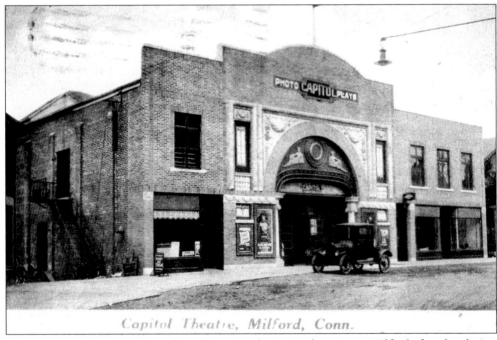

CAPITOL THEATER. This was the only movie theater in downtown Milford after the closing of the Colonial. It was located on Daniel Street until it was demolished to make room for expanding businesses.

FOWLER MEMORIAL. The photograph above shows the Fowler Memorial building in 1914 as it was being completed. Built on the site of the Fowler homestead, it became the meeting place for the American Legion Post 34. Below is the rebuilt building as seen in 1930. It is now the site of the Milford Library.

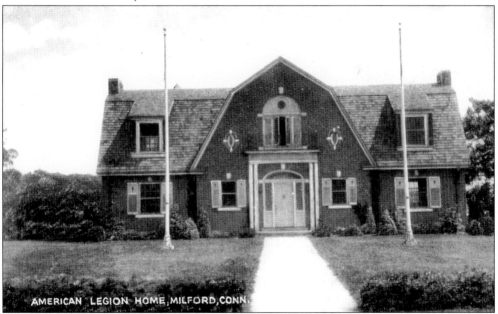

AMERICAN LEGION HOME, MILFORD, CONN.

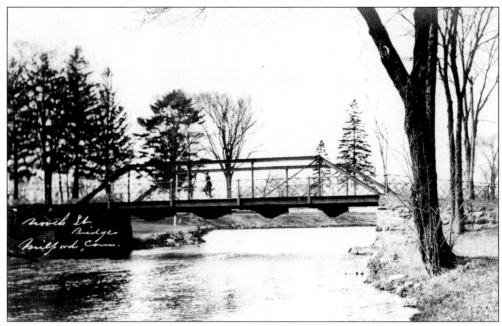

NORTH STREET BRIDGE AND DAM. Above a girl rides a bicycle across the North Street Bridge toward Maple Street about 1910. Below is a view of the dam from the bridge, looking toward North Street.

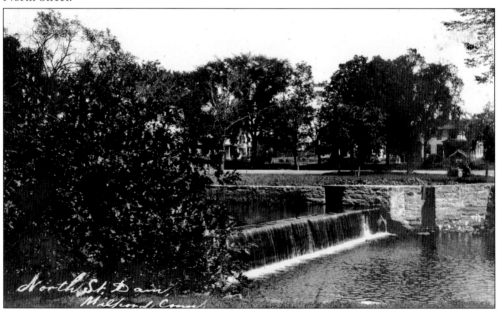

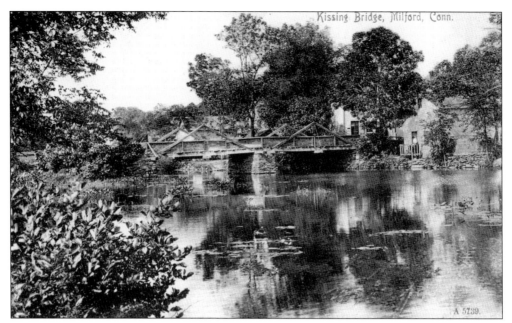

KISSING BRIDGE. Above is a view of the old wooden footbridge actually named the Jehiel Bristol Bridge but commonly called the Kissing Bridge. In the 1920s, the bridge was replaced by the concrete Colonel Mazeau Bridge to accommodate automobile traffic. This bridge is shown below.

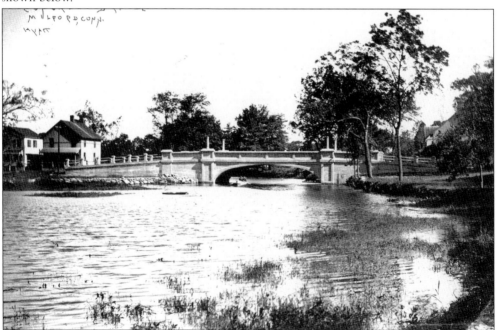

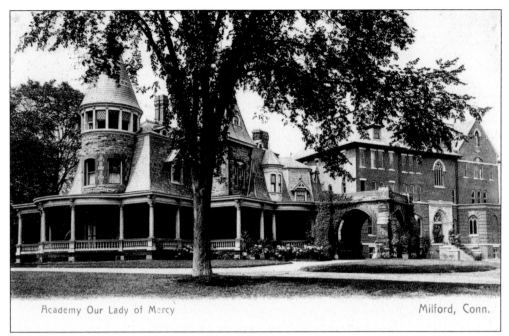

Academy Our Lady of Mercy Milford, Conn.

LAURALTON HALL. Originally the 23-acre estate of Charles Pond, the Academy of Our Lady of Mercy, also known as Lauralton Hall, was established in 1905. The estate can be seen above. The massive rectory building shown below was used to house and educate the students at the all-female private school.

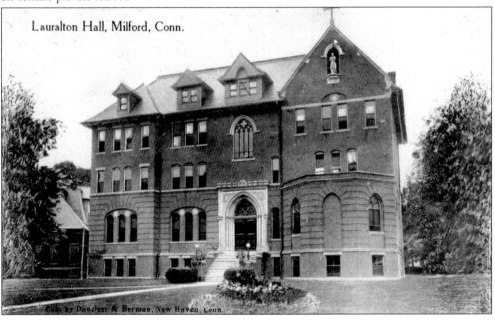

Lauralton Hall, Milford, Conn.

Pub. by Danziger & Berman, New Haven, Conn.

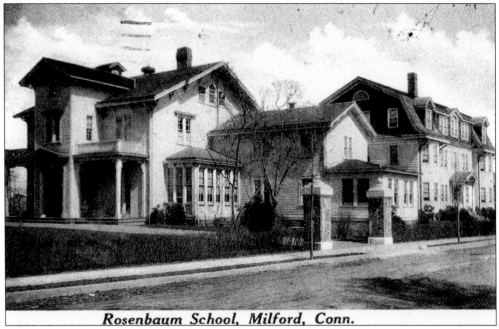

Rosenbaum School, Milford, Conn.

MILFORD SCHOOL. The school shown above was created in 1916 as a preparatory school for boys by Samuel and Harris Rosenbaum. The William Pond house served as the administration building and dining hall for the Milford School. To the right is Morris Hall, which served as a dormitory. Below is a view from the corner of Gulf Street and New Haven Avenue. The property is now owned by the City of Milford.

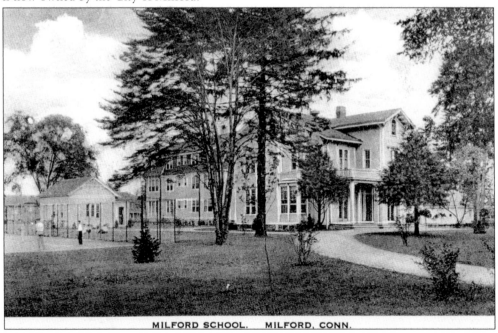

MILFORD SCHOOL. MILFORD, CONN.

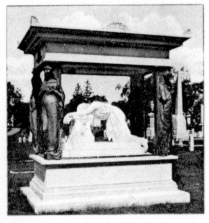

Downes
Mausoleum

Grinnell Monument
Milford, Conn.

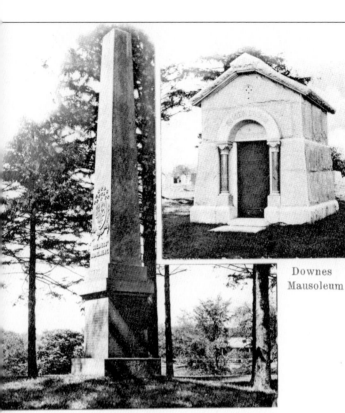

Soldiers Monument

SOLDIERS' MONUMENT. Located in Milford Cemetery, this memorial was built in 1852 to honor 46 Revolutionary War soldiers who were prisoners of war. In the winter of 1776, the British put 200 men ashore in the dark near Fort Trumbull. Many soldiers were wounded and sick, but Capt. Stephen Stowe and other Milford citizens nursed most back to health. Those who died were buried in a common grave on this spot.

Three

THE HARBOR AND
CHARLES ISLAND

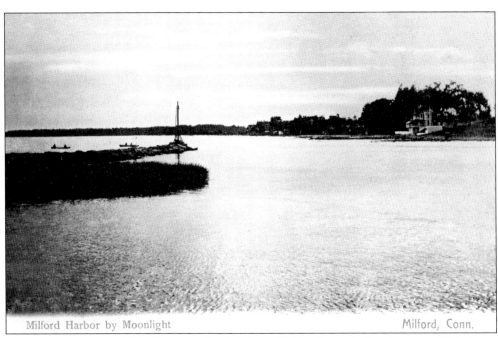

Milford Harbor by Moonlight Milford, Conn.

HARBOR ENTRANCE. This view from the Gulf Street Bridge shows the breakwater and lighthouse off Gulf Beach and Fort Trumbull on the opposite shore.

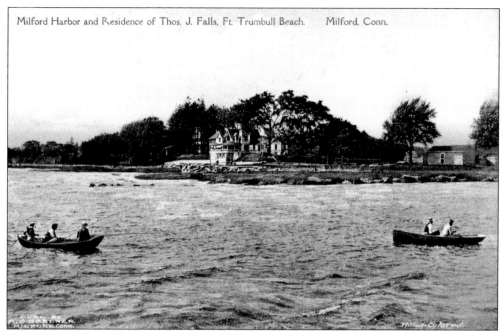

Milford Harbor and Residence of Thos. J. Falls, Ft. Trumbull Beach. Milford, Conn.

FORT TRUMBULL. Fort Trumbull was built at West Point on high ground at the entrance to Milford Harbor to protect against the British. Built in 1776, the fort housed a garrison of men along with four cannons. These two views show the fort intact. This historic site is now a condominium.

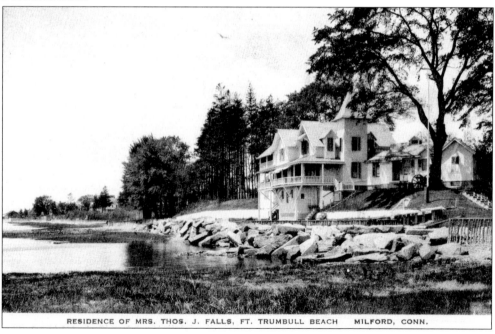

RESIDENCE OF MRS. THOS. J. FALLS, FT. TRUMBULL BEACH MILFORD, CONN.

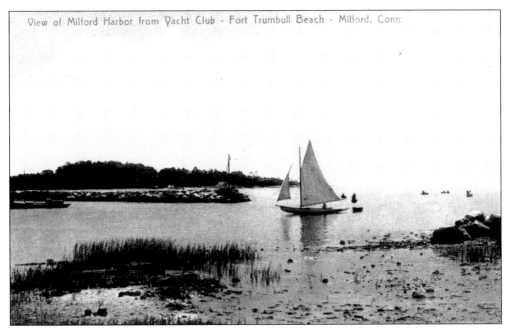

View of Milford Harbor from Yacht Club - Fort Trumbull Beach - Milford, Conn.

BREAKWATER. A gaff-rigged sailboat enters Milford Harbor through the breakwaters on each side (above). Taken from the foot of the Fort Trumbull jetty, one can see the lighthouse on the east side. The opposite view is shown below, as fishermen on the breakwater try their luck. Fort Trumbull and the Milford Yacht Club are in the distance.

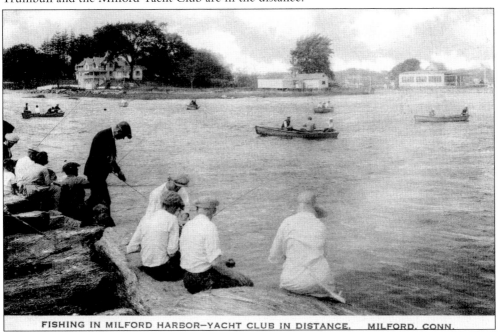

FISHING IN MILFORD HARBOR—YACHT CLUB IN DISTANCE. MILFORD, CONN.

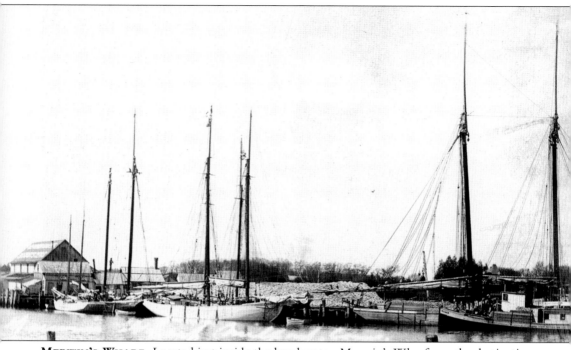

MERWIN'S WHARF. Located just inside the breakwater, Merwin's Wharf was the destination for Milford's oyster fleet. This real-photo postcard, taken from the yacht club around 1906, shows the sailing ships that were used before gasoline engines came to dominate the industry. The large building on the left is the shucking house. Outside, covering all available space, is a huge mound of oyster shells waiting to be taken back to the oyster beds. This location has been converted to luxury condominiums.

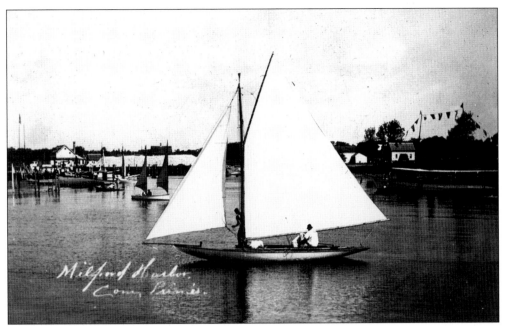

MILFORD HARBOR. Above a sleek period sailboat prepares to leave the sheltered harbor at slack tide. The yacht club committee boat is in the background with flags flying from both masts. The view below shows the harbor docks from across the harbor.

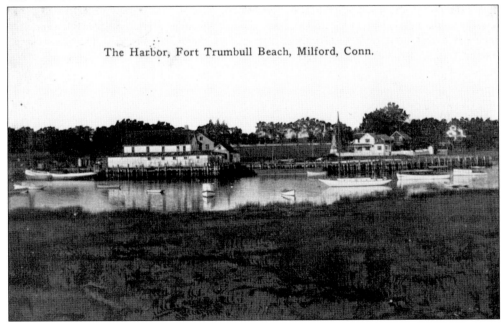

The Harbor, Fort Trumbull Beach, Milford, Conn.

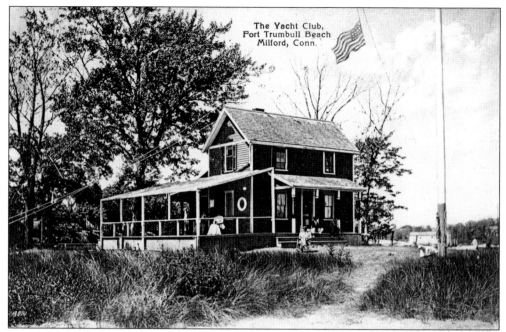

MILFORD YACHT CLUB. Organized in 1903 by Dr. Willis Putney, the original clubhouse on Fort Trumbull Beach, at the mouth of the harbor, is shown in this postcard. Still in its original location today, the Milford Yacht Club merged with the Wepawaug Yacht Club in 1934. The sign says "Members Only."

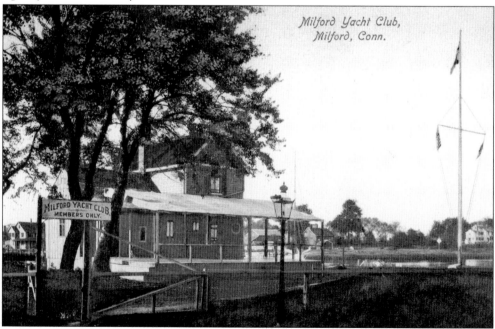

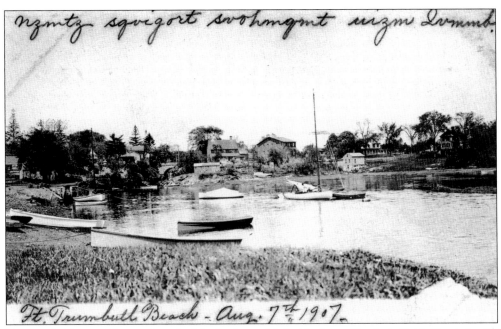

nzmtz sgvigort svohmgmt uizm Lvmmb

Ft. Trumbull Beach - Aug. 7th 1907 -

FOWLER'S FIELD. The north end of the harbor at high tide shows Fowler's Field, flooded with water, behind the anchored boats. Now raised above the tide, it is the site of many town activities and has a boat-launching ramp.

STRAW FACTORY. Before World War I, the Flagg and Baldwin Straw Factory was one of the city's biggest employers. It is located at the head of the harbor on Factory Lane, just off the town green.

45

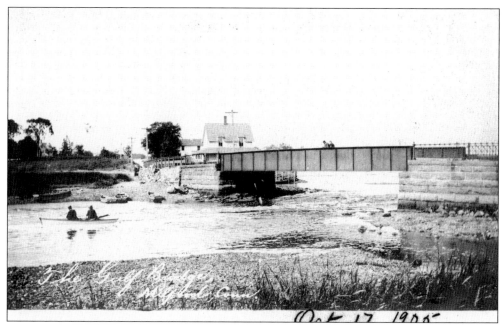

GULF STREET BRIDGE. Two men in a small boat ride the outgoing current under the Gulf Street Bridge in 1905. The bridge is still in place as a fishing bridge.

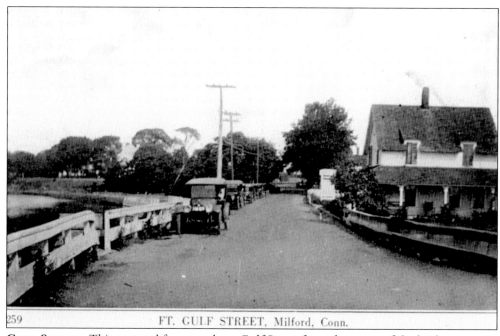

FT. GULF STREET, Milford, Conn.

GULF STREET. This postcard faces north up Gulf Street from the apron of the bridge.

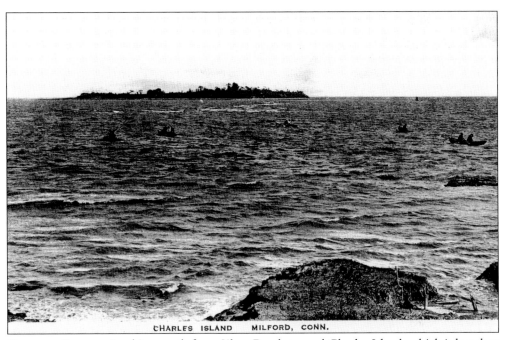

CHARLES ISLAND MILFORD, CONN.

CHARLES ISLAND. Looking south from Silver Beach toward Charles Island, which is less than a mile offshore, the boats are fishing the submerged sandbar.

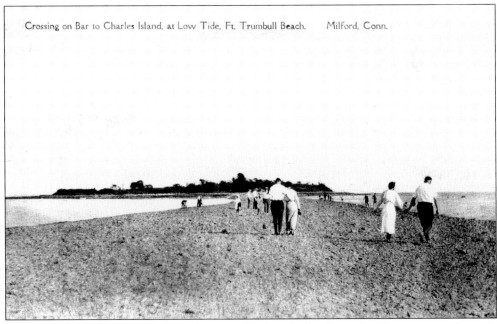

Crossing on Bar to Charles Island, at Low Tide, Ft. Trumbull Beach. Milford, Conn.

CHARLES ISLAND BAR. People walk out to Charles Island at low tide. Then, as now, the wide sandbar allows visitors to explore the ruins on the island.

ON CHARLES ISLAND. This is a view from Charles Island back toward the shore. Ruins of a religious sanctuary, a resort hotel, and the story of Captain Kidd's treasure lure many to explore this unique island. Today the island is a bird sanctuary, and visitation is restricted.

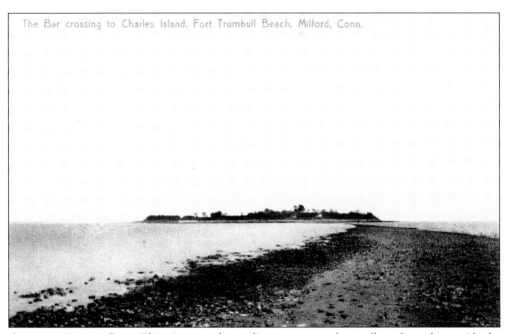

The Bar crossing to Charles Island, Fort Trumbull Beach, Milford, Conn.

CHARLES ISLAND BAR. This picture, taken a distance out on the sandbar, shows how wide the bar was at low tide. People drove early cars out to the island.

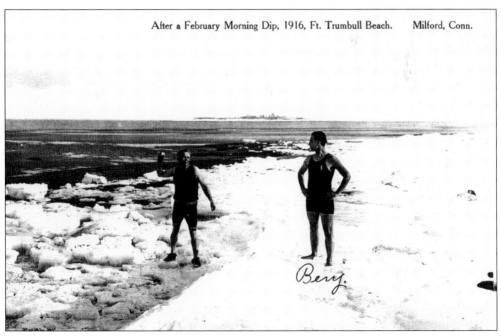

After a February Morning Dip, 1916, Ft. Trumbull Beach. Milford, Conn.

WINTER BEACH. Two hardy campers, on the snow-covered beach, mug for the camera. Charles Island is in the background.

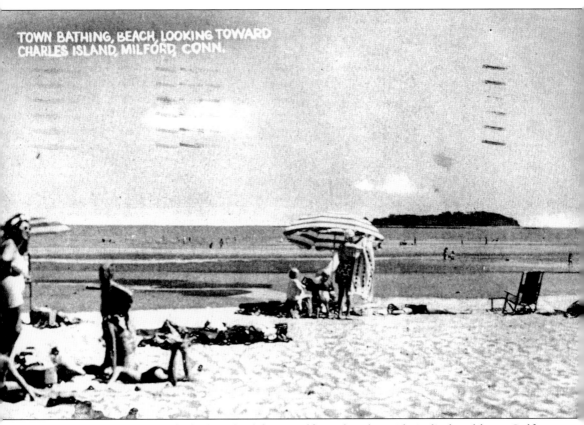

GULF BEACH. A view of Charles Island from Gulf Beach at low tide is displayed here. Gulf Beach is the primary public beach to the east of the harbor and has no houses as it backs up to Indian River, Gulf Pond, and the surrounding marshes.

Four

FORT TRUMBULL BEACH AND SILVER BEACH

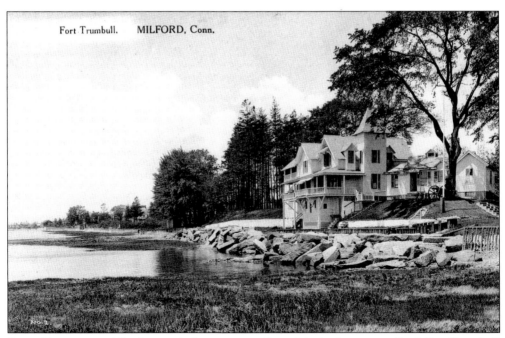

Fort Trumbull. MILFORD, Conn.

FORT TRUMBULL. After its practical use as a guardian of the harbor was realized, Fort Trumbull became a private residence. This was the first building off the beach area that bears its name.

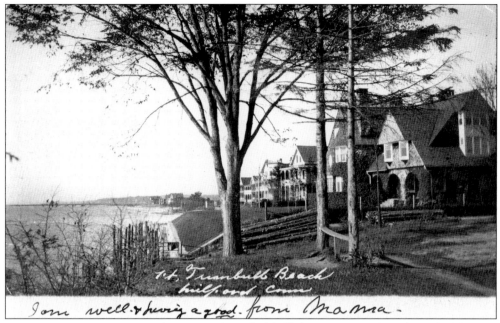

Ft. Trumbull Beach (handwritten on photo)
Milford, Conn (handwritten on photo)
I am well + having a good. from Mama - (handwritten on photo)

FORT TRUMBULL BLUFF. Looking west along the bluff, this view extends to the end of the Fort Trumbull property. The large private residences can be seen overlooking the narrow beach.

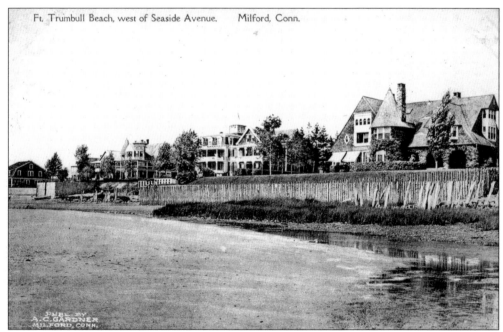

Ft. Trumbull Beach, west of Seaside Avenue. Milford, Conn.

PUBL BY
A.C.GARDNER
MILFORD, CONN.

THE GABLES. The dominant house in this view of Fort Trumbull Beach is named the Gables. It was built by Augustus Taylor in the 1880s as a family summer retreat. It is now a condominium.

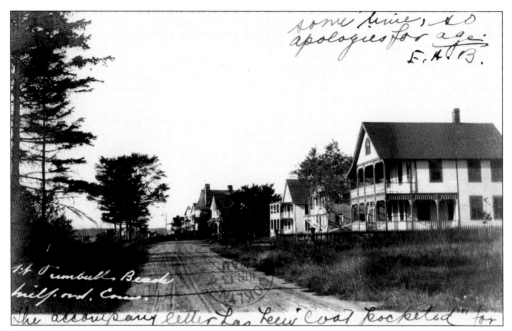

TRUMBULL AVENUE. Unpaved in 1913, Trumbull Avenue runs along the high ground of Fort Trumbull Beach. The Gables can be seen at the far end of the street.

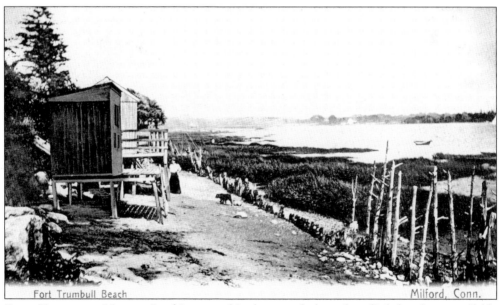

Fort Trumbull Beach Milford, Conn.

FORT TRUMBULL MARSH. Looking east, this photograph shows how little beach was available below the high ground. The dense marshes seen actually protected the bluff from erosion.

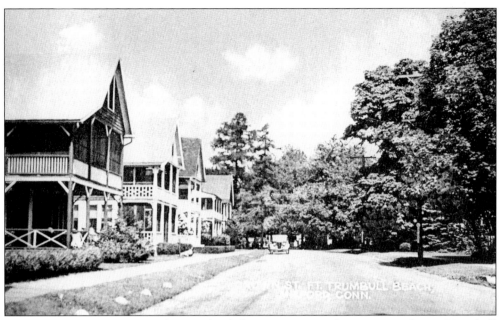

FORT TRUMBULL BEACH. High ground and close proximity to downtown made Fort Trumbull Beach more than a resort area, as seen in these two postcards. The view above looks down Crown Street, and below one can see Elm Street from Baldwin Avenue. The white band with a "T" marks the trolley stop.

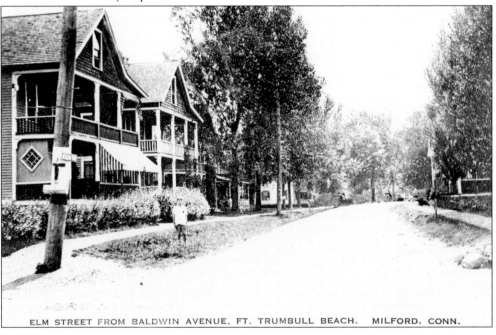

ELM STREET FROM BALDWIN AVENUE, FT. TRUMBULL BEACH. MILFORD, CONN.

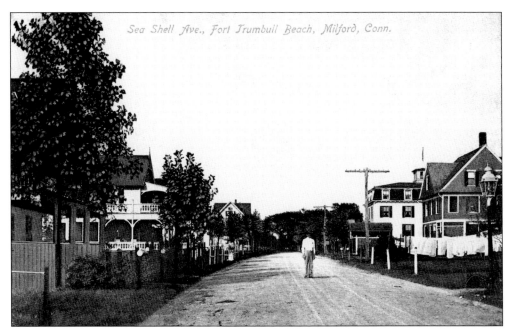

Sea Shell Ave., Fort Trumbull Beach, Milford, Conn.

FORT TRUMBULL STREETS. Above a man walks down Sea Shell Avenue past drying laundry. This quiet street runs parallel to Baldwin Avenue, the trolley route. Below are the trolley tracks on Baldwin as it goes past Maple Street. Baldwin has been absorbed by East Broadway and is still the scenic road along the shore heading west.

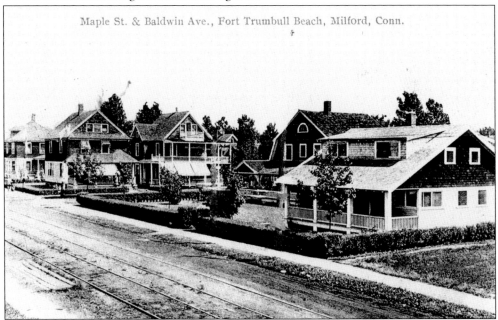

Maple St. & Baldwin Ave., Fort Trumbull Beach, Milford, Conn.

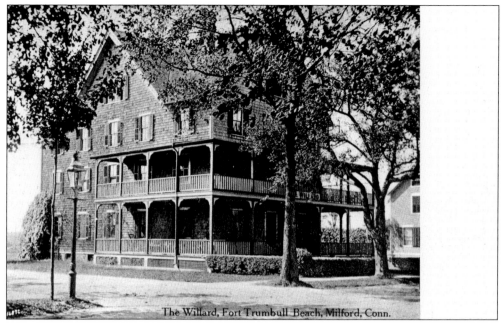

The Willard, Fort Trumbull Beach, Milford, Conn.

THE WILLARD. Perched on Fort Trumbull bluff, this guesthouse gave its patrons a view of Long Island Sound and Charles Island.

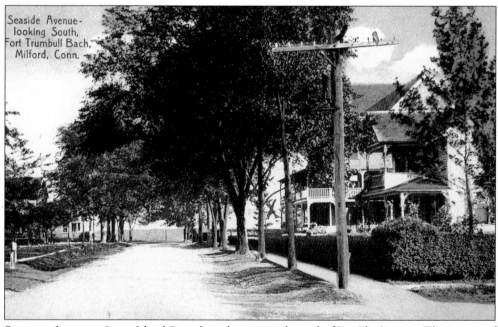

Seaside Avenue - looking South, Fort Trumbull Bach, Milford, Conn.

SEASIDE AVENUE. Long Island Sound can be seen at the end of Seaside Avenue. The corner of the Willard is visible on the right-hand side.

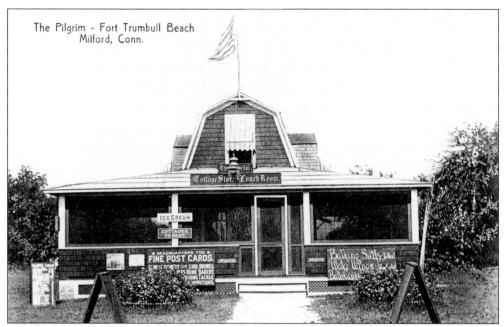

The Pilgrim - Fort Trumbull Beach
Milford, Conn.

THE PILGRIM. Located on the corner of East Broadway and Seaside Avenue, the Pilgrim offered Fort Trumbull vacationers everything from bathing suit rentals and water wings to postcards and fishing tackle. The Cottage Store Lunch Room operated on the porch. The Pilgrim staff sells ice cream and drinks in the yard in the postcard below.

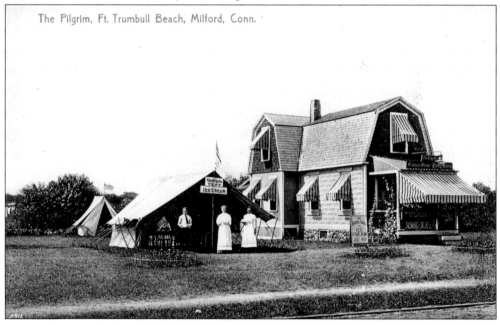

The Pilgrim, Ft. Trumbull Beach, Milford, Conn.

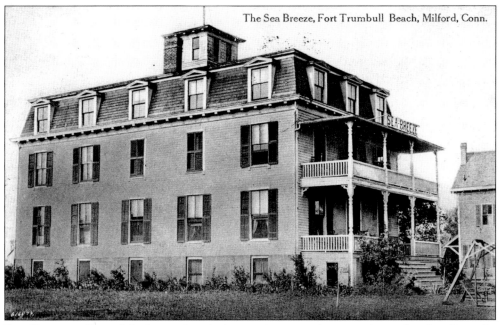

The Sea Breeze, Fort Trumbull Beach, Milford, Conn.

SEA BREEZE. One of the largest hotels, its two large porches were just a few feet from the wooden breakwater, 10 feet above the water's edge.

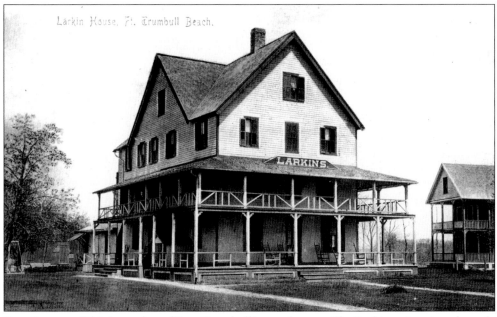

Larkin House, Ft. Trumbull Beach.

THE LARKIN. This is another of Fort Trumbull's guesthouses. The Larkin epitomizes the style of the turn of the 20th century waterfront beach house.

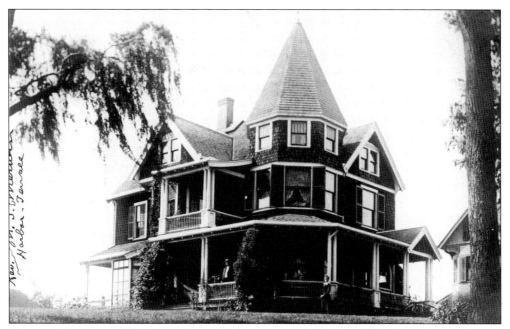

HARBOR TERRACE. This image is a real-photo postcard of a beautiful private home, given as a Christmas card in 1906. The man on the porch is identified as Reverend Merwin.

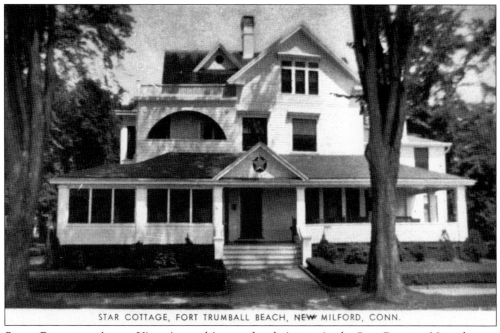

STAR COTTAGE, FORT TRUMBALL BEACH, NEW MILFORD, CONN.

STAR COTTAGE. A post-Victorian architectural style is seen in the Star Cottage. Note the star over the front entrance.

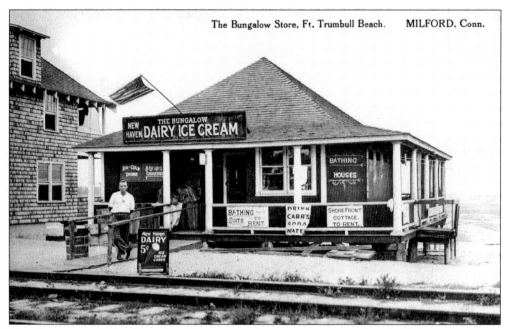

The Bungalow Store, Ft. Trumbull Beach. MILFORD, Conn.

THE BUNGALOW. The Bungalow (above) contained a grocery store that faced the trolley tracks on East Broadway. In the postcard below, the Bungalow from the beach shows the line of cottages on the low ground, and the creek draining the salt marsh cuts across the beach.

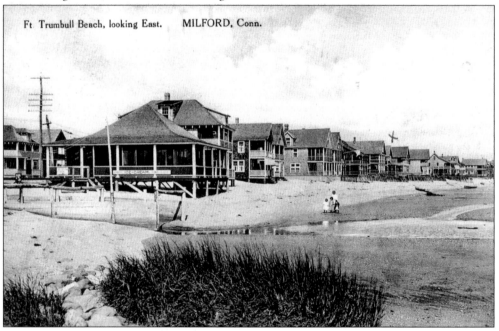

Ft. Trumbull Beach, looking East. MILFORD, Conn.

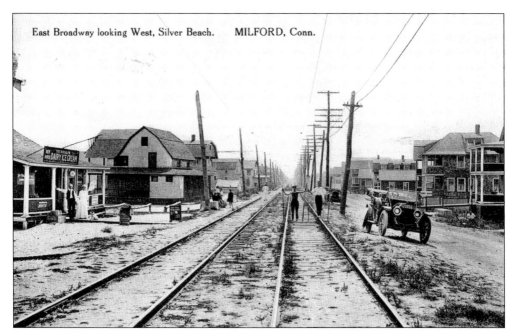

East Broadway looking West, Silver Beach. MILFORD, Conn.

SILVER BEACH. The image above was taken from Fort Trumbull Beach looking west toward Silver Beach, showing the trolley tracks and the automobile road to the right. The Bungalow is on the left. The view below faces east down East Broadway from Silver Beach.

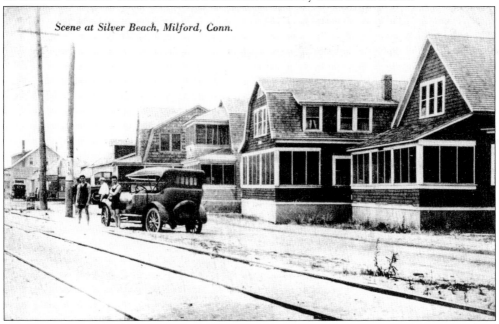

Scene at Silver Beach, Milford, Conn.

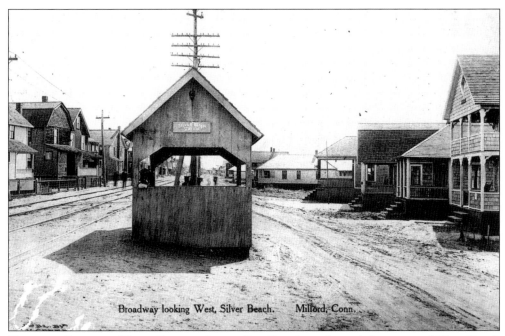

Broadway looking West, Silver Beach. Milford, Conn.

TROLLEY STATION. The trolley running on East Broadway formed the center of Silver Beach due to the marshes on the north and the sound to the south.

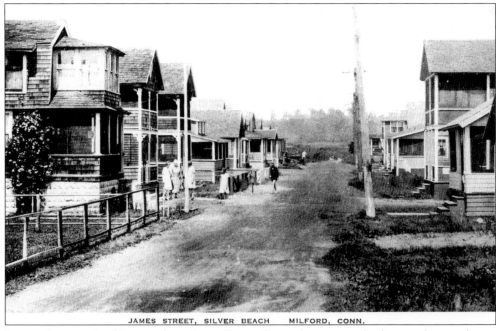

JAMES STREET, SILVER BEACH MILFORD, CONN.

JAMES STREET. Looking north on James Street shows the cottages leading to the marshes at the end of the street.

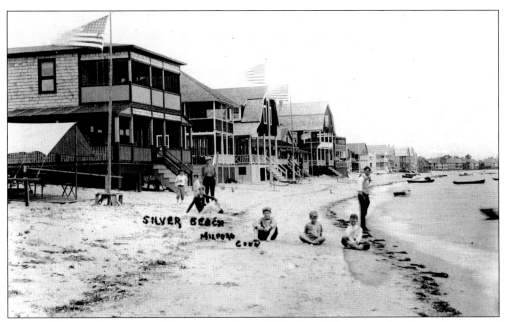

SILVER BEACH COTTAGES. These two views of the beach face east, showing cottages and bathers. It seems like everyone in town owned a small boat.

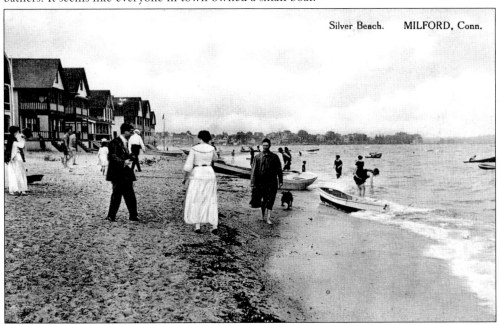

Silver Beach. MILFORD, Conn.

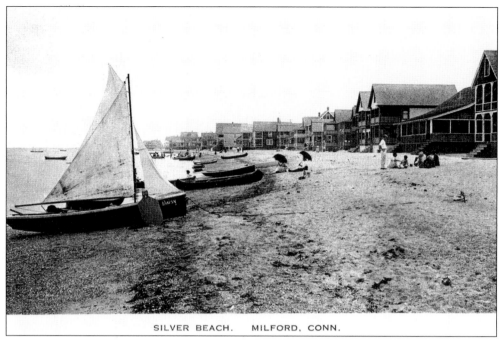

SILVER BEACH. MILFORD, CONN.

SILVER BEACH ACTIVITIES. Above a sailboat pulls up on the beach with its centerboard leaning against the hull. Shallow water made this type of boat essential. Below, a crowd of bathers walks Silver Beach. Some are wading out on the sandbar that will take them to Charles Island as the six-foot tide goes out.

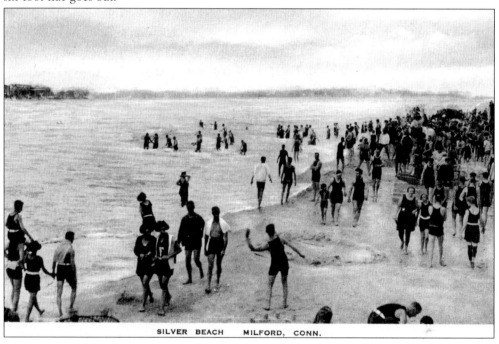

SILVER BEACH MILFORD, CONN.

Five

MYRTLE BEACH

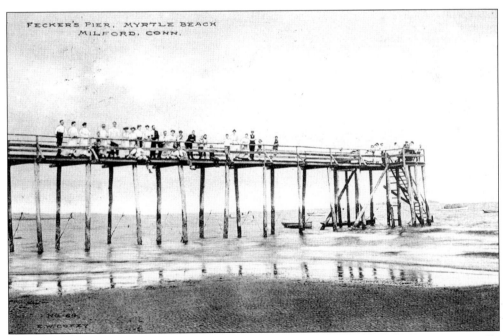

FECKER'S PIER, MYRTLE BEACH
MILFORD, CONN.

FECKER'S PIER. A crowd poses for a picture about 1910. This pier was a big attraction, especially for fishermen who wanted to get out to deeper water.

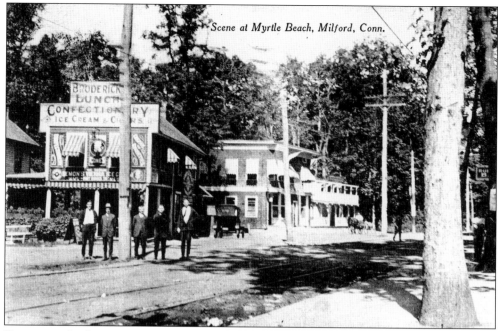

BRODERICK'S. An eastern view on East Broadway shows Broderick's confectionary store, where lunch was also served, at Myrtle Beach.

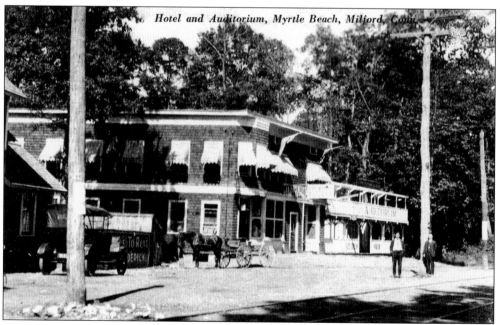

MYRTLE BEACH HOTEL. Located just past Broderick's, this hotel was one of many places to stay in Myrtle Beach. The building to the right is identified as the Auditorium but looks more like an ice-cream stand.

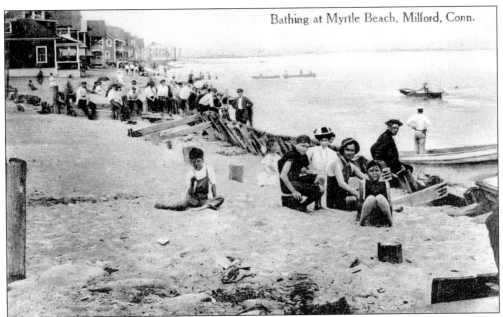

Bathing at Myrtle Beach, Milford, Conn.

MYRTLE BEACH. Bathers in 1917 (above) enjoy the sandy beach behind the wooden breakwater while wearing the modest beach attire of the day. Below a man waits for the tide to come in so he can launch his boat. Behind him is Lorelei cottage. Most cottages at the beach were named.

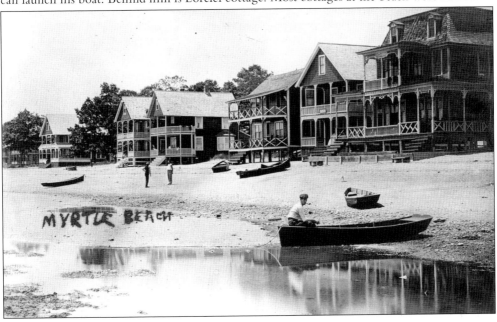

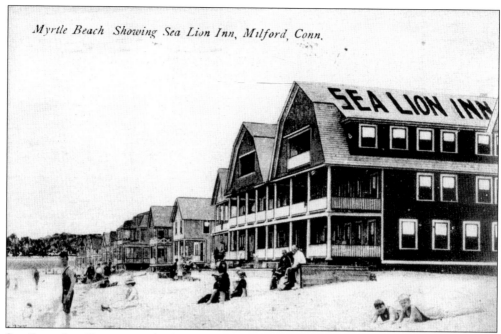

Myrtle Beach Showing Sea Lion Inn, Milford, Conn.

SEA LION INN PORCHES. The double-barn roofed hotel above was known for its dining room and location, looking out on Long Island Sound. Below there is a view of the expansive upper porch connecting the two buildings that form the Sea Lion Inn.

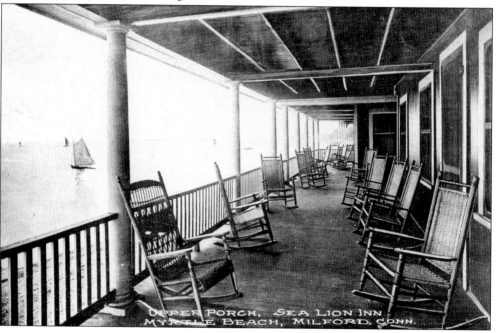

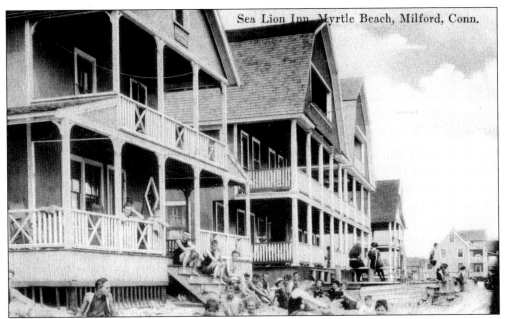

SEA LION INN. The inn faces west above, with guests on the steps of the cottage next door. Below, the rustic dining room with beamed ceiling and fireplace attracts vacationers and locals to the Sea Lion Inn to sample the local seafood.

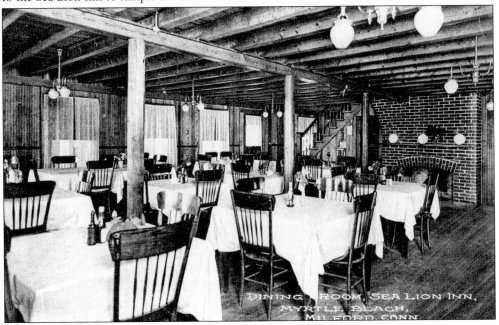

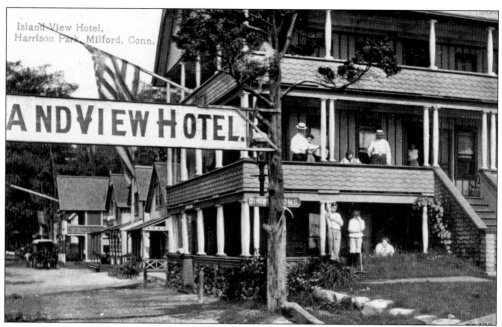

ISLAND VIEW HOTEL FROM LONG ISLAND SOUND. The image above, looking north on Grove Street, shows the corner of the Island View Hotel and the large sign visible to boaters on Long Island Sound. The pier below served guests and fishermen and also allowed boaters to dock and visit the hotel.

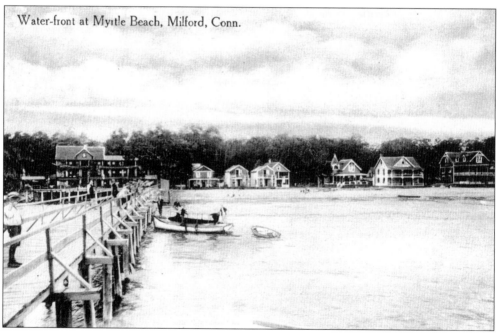

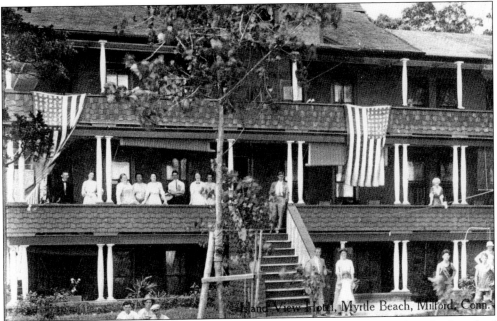

ISLAND VIEW HOTEL. The waterfront porches shown above display the hotel on the Fourth of July. The view below faces south on Grove Street past an early gas pump, and the Island View is the last building on the left.

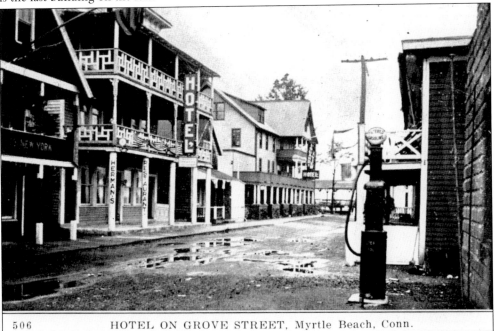

506 HOTEL ON GROVE STREET, Myrtle Beach, Conn.

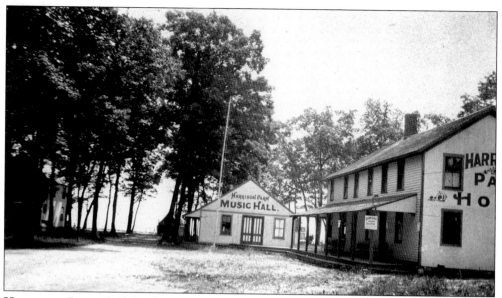

HARRISON PARK. Built by the trolley company, the music hall attracted visitors to this part of Myrtle Beach for concerts by the water. Rooms were also available for overnight guests.

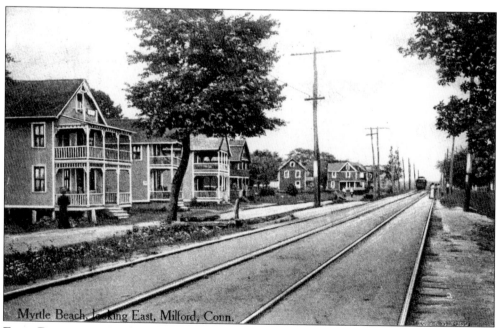

Myrtle Beach, looking East, Milford, Conn.

EAST BROADWAY. Looking east down East Broadway, a trolley in the distance heads west toward the viewer.

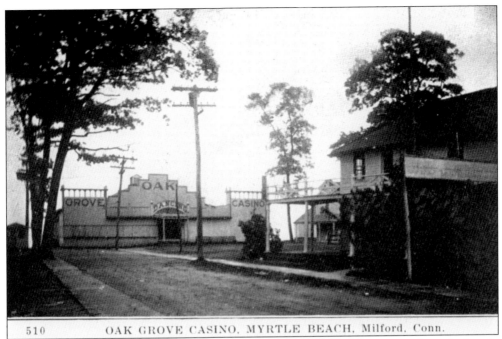

510 OAK GROVE CASINO, MYRTLE BEACH, Milford, Conn.

OAK GROVE CASINO. If dancing was one's thing, this is where one wanted to be at the beach. The building extended out over the water and is actually located in Walnut Beach.

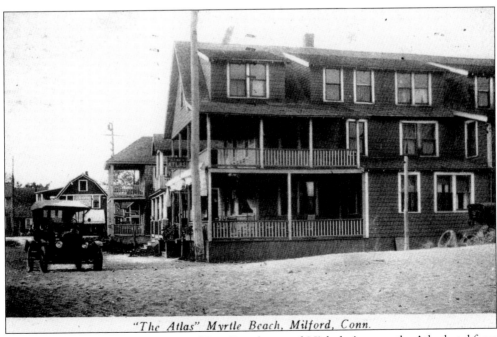

"The Atlas" Myrtle Beach, Milford, Conn.

THE ATLAS. Located at the corner of East Broadway and Nichols Avenue, the Atlas hotel faces a sand–covered street.

73

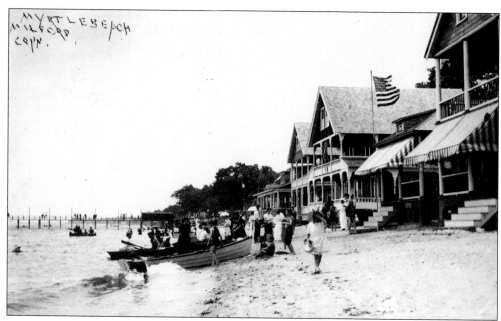

MYRTLE BEACH WEST. The two views on this page are of the beach looking west. As usual along Milford beaches, small boats are seen everywhere.

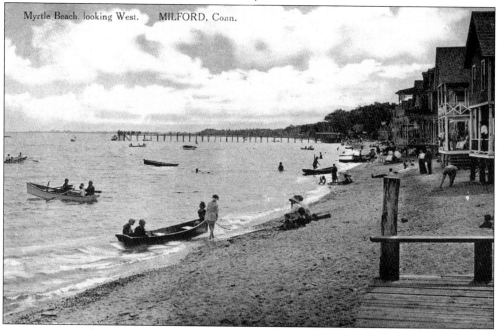

Six

WALNUT BEACH AND WILDEMERE BEACH

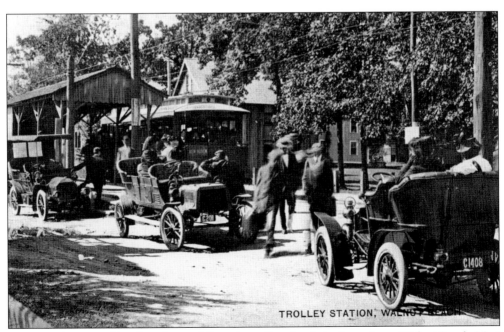

TROLLEY STATION. People rush to and from the trolley already in the station at Walnut Beach. Most of Milford's beaches would have been difficult to reach were it not for the extensive trolley system.

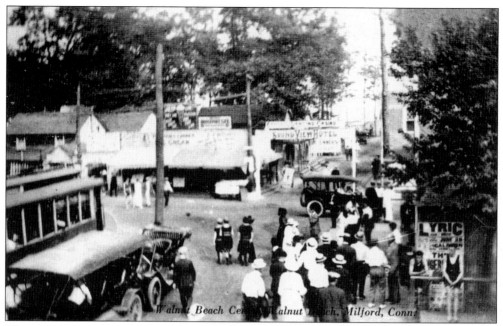

Walnut Beach Ce...alnut Beach, Milford, Conn.

WALNUT BEACH CENTER. The postcard above shows what a busy place Walnut Beach was in 1920. One can see below that when church was over, everyone headed past Dillane's bakery.

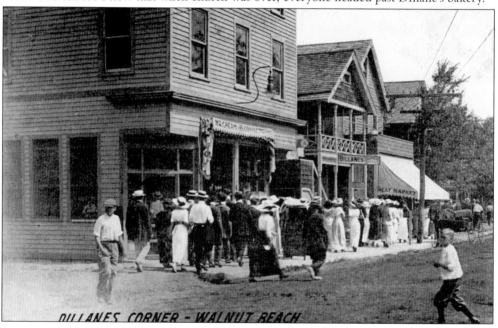

DILLANES CORNER - WALNUT BEACH

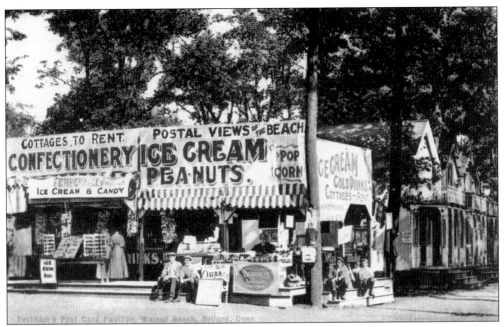

TINKHAM'S CORNER. Tinkham's postcard pavilion was the place where one could get the best selection of postcards to send back home, not to mention ice cream, peanuts, and "temperance" drinks.

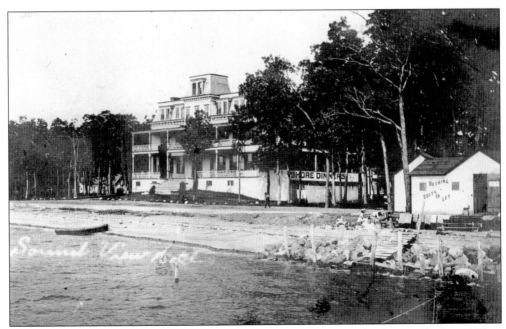

SOUND VIEW HOTEL. Built on a large property surrounded with tall oak trees, the Sound View was the premier hotel at Walnut Beach.

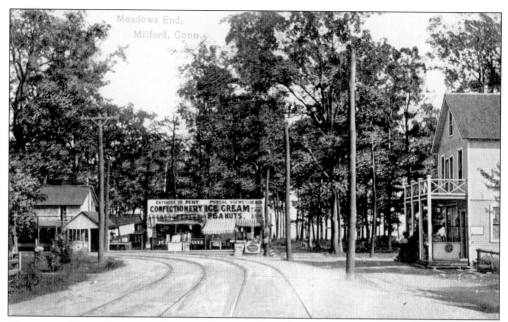

MEADOWS END. The view above is of an area long known as Meadows End, formed by the junction of Naugatuck Avenue and East Broadway. The building on the right is the Idle Hour. The reverse view can be seen below, looking west with the trolley station on the right.

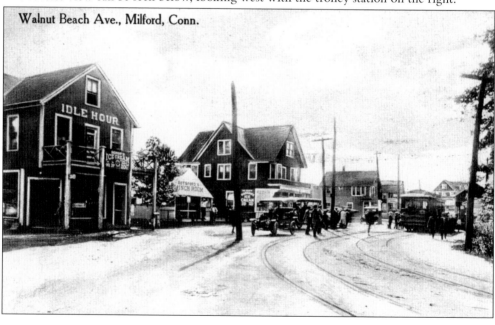

Walnut Beach Ave., Milford, Conn.

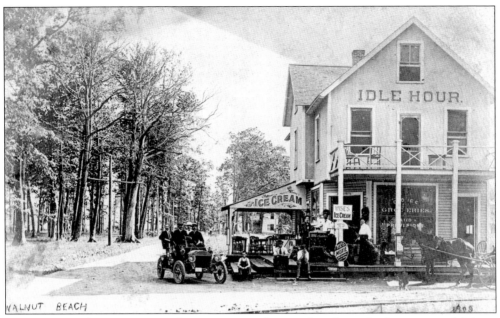

IDLE HOUR. The grocery store above was a popular meeting place whether one was driving a car or a horse. Just to the left is the entrance to the Sound View Hotel. The Idle Hour is shown from the north below. Tinkham's is on the distant left.

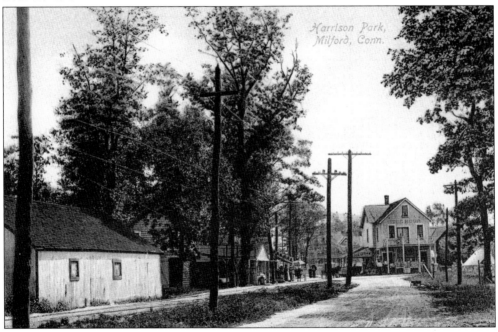

79

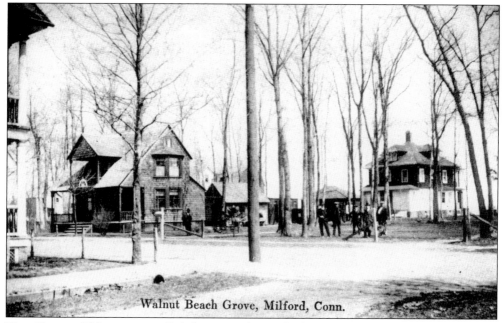

Walnut Beach Grove, Milford, Conn.

THE GROVE. This area was called the Grove due to the large trees and open space. Originally used as a picnic area, it later became prime seaside real estate.

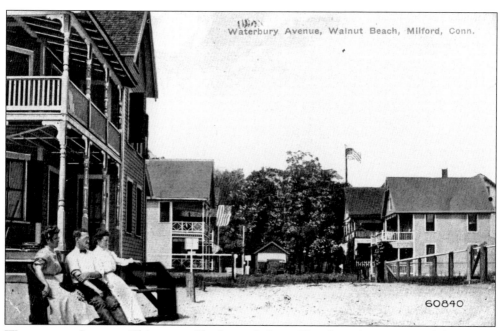

Waterbury Avenue, Walnut Beach, Milford, Conn.

60840

WATERBURY AVENUE. This postcard looks north down Waterbury Avenue toward the Walnut Beach Chapel, just out of view to the left.

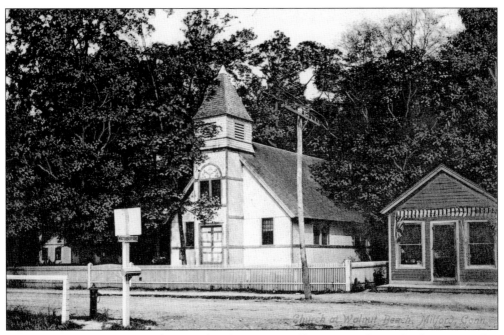

WALNUT BEACH CHAPEL. This tiny church was originally a meetinghouse for the community. Built in 1895, it became the Walnut Beach Union Chapel in 1923. In the postcard below, wedding guests greet the newlyweds as they leave the chapel.

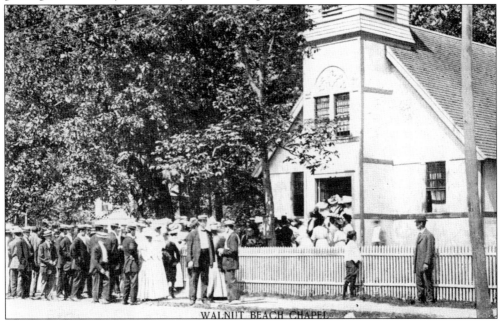

WALNUT BEACH CHAPEL

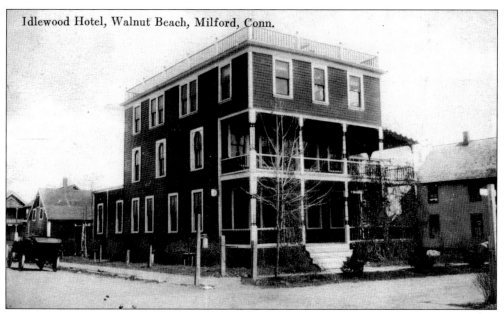

Idlewood Hotel, Walnut Beach, Milford, Conn.

IDLEWOOD. This area was a very popular place to stay at the beach. Many postcards were sent listing this guesthouse as the place visitors were staying.

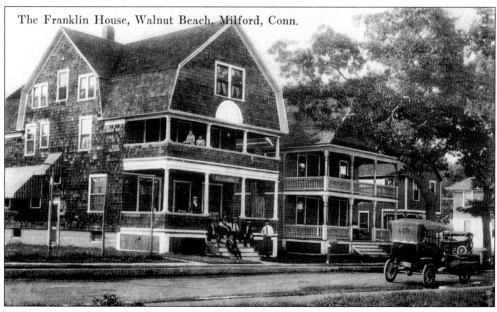

The Franklin House, Walnut Beach, Milford, Conn.

FRANKLIN HOUSE. Seen here is just one of the many guest houses at Walnut Beach which accommodated the summer visitors.

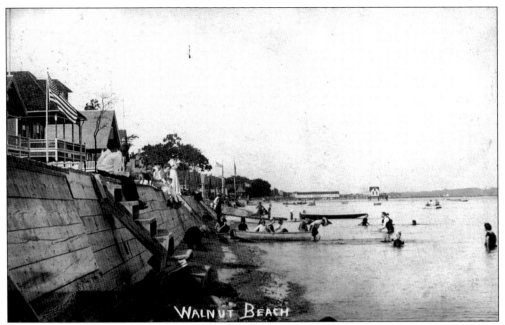

WALNUT BEACH. The view above faces north along the wooden breakwater. The bathers below use a rope to venture out in the water. Most people in this era were not swimmers.

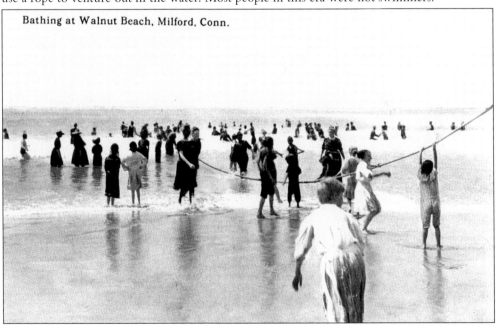

Bathing at Walnut Beach, Milford, Conn.

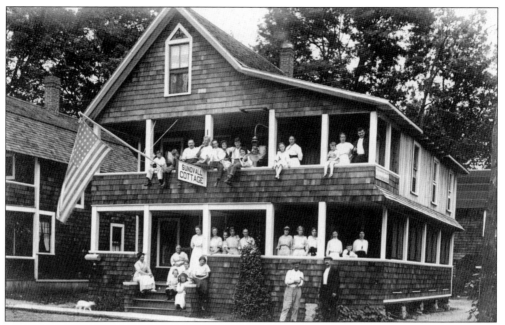

SUNDVALL. Everyone staying at the Sundvall was called out on the porch for a Fourth of July photograph.

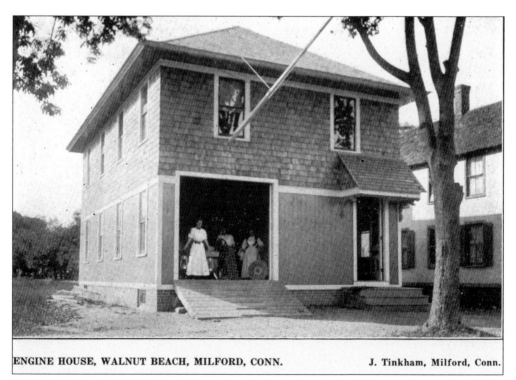

ENGINE HOUSE, WALNUT BEACH, MILFORD, CONN. J. Tinkham, Milford, Conn.

ENGINE HOUSE. This small firehouse enlisted many volunteer firefighters who were kept busy pulling the two-wheeled hose cart.

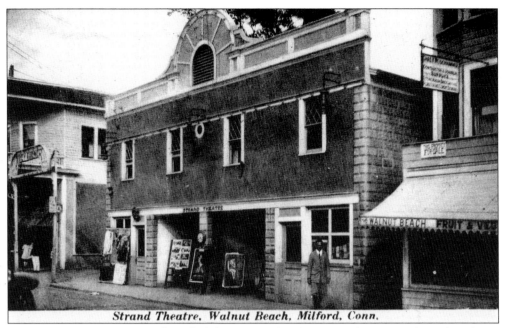

Strand Theatre, Walnut Beach, Milford, Conn.

STRAND THEATRE. Originally called the Strand, this theater was known as the Colonial into the 1950s. It was the second movie house built in Milford.

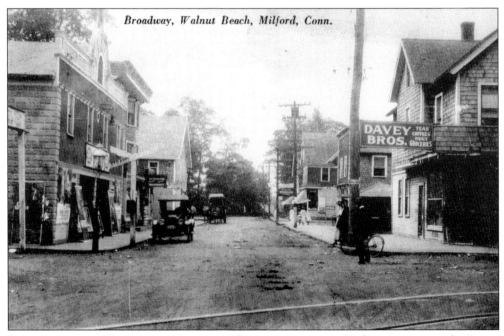

Broadway, Walnut Beach, Milford, Conn.

BROADWAY AND NAUGATUCK AVENUE. This corner was popular for two reasons: the Davey Brothers grocery store on the right and the Strand Theatre across the street on the left.

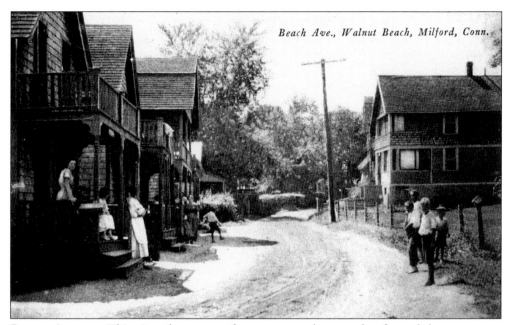

BEACH AVENUE. This view shows one of many unpaved streets that formed the permanent residences of Walnut Beach.

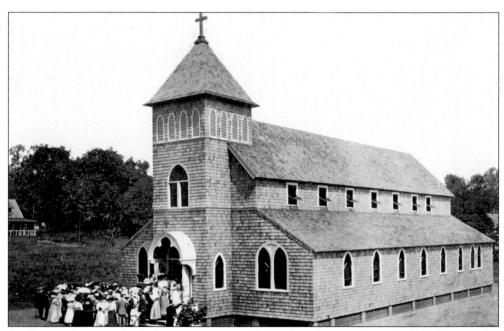

ST. GABRIEL'S. Located at Andrews Avenue, St. Gabriel's Church was dedicated in 1910. The wooden structure shown here was destroyed by fire in 1923. Rebuilt, it remains at this location today.

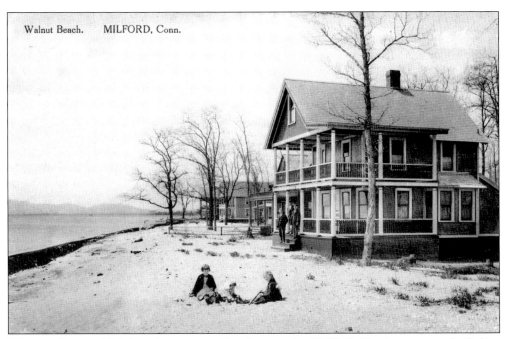

Walnut Beach. MILFORD, Conn.

WALNUT BEACH. This is a winter postcard by photographer E. W. Coffey that captures the feeling of the moment. Coffey took many of the photographs that became postcards of Milford.

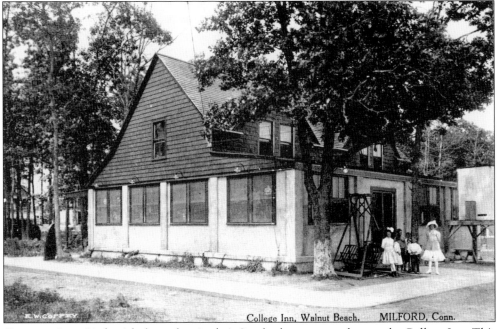

College Inn, Walnut Beach. MILFORD, Conn.

COLLEGE INN. Little girls dressed up in their Sunday best are seen here at the College Inn. This business is typical of the many family-run shops at Walnut Beach.

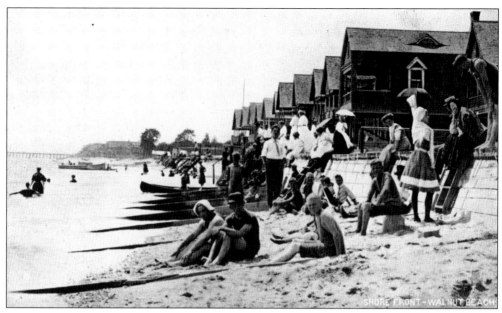

WILDEMERE BEACH. One can see a scene on Walnut Beach above, looking south toward Wildemere. The cottages and beach at Wildemere Beach can be seen below, facing north.

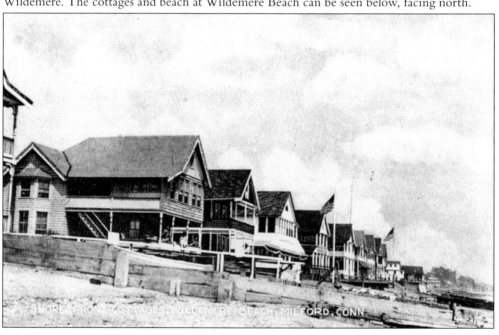

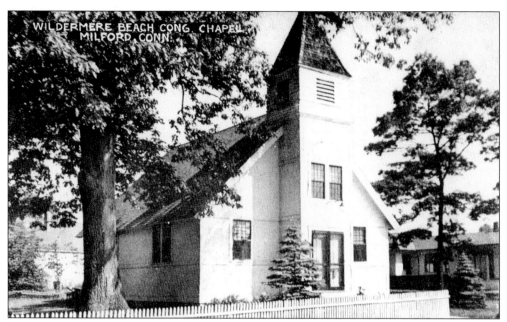

WILDEMERE CHAPEL. This chapel is claimed by both Walnut Beach and Wildemere Beach residents. It is currently the Wildemere Beach Congregational Church.

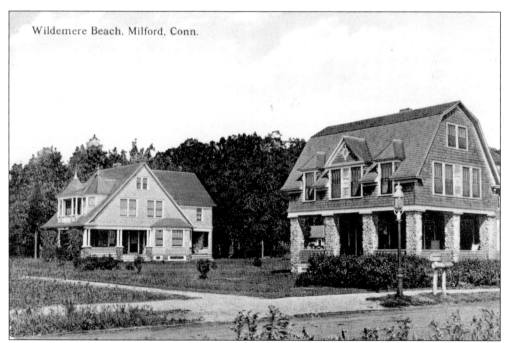

WILDEMERE COTTAGES. Away from the threat of damaging shorefront flooding, large family residences were built for year-round use.

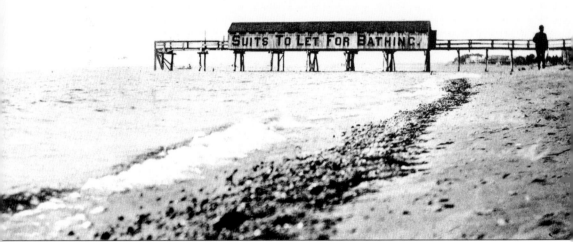

Bathing Beach- Walnut Beach
Milford, Conn.

SUITS TO LET FOR BATHING.

WILDEMERE BEACH. This view looks west on Wildemere Beach toward the fishing and bathing pier. Beachgoers could change into their rental suits in the enclosed area while fishermen cast their lines from the end. Originally this pier was longer with a wide area at the end supporting a small house.

Seven

Laurel Beach, Cedar Beach, and Milford Point

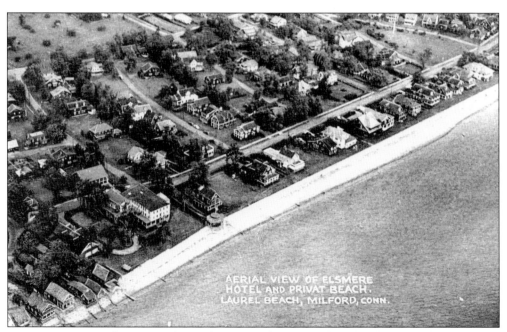

AERIAL VIEW OF ELSMERE HOTEL AND PRIVAT BEACH. LAUREL BEACH, MILFORD, CONN.

Laurel Beach. This image shows the private beach and boardwalk at Laurel Beach. East Broadway can be seen running parallel to the beach. The large white building on the left is the Elsmere Hotel.

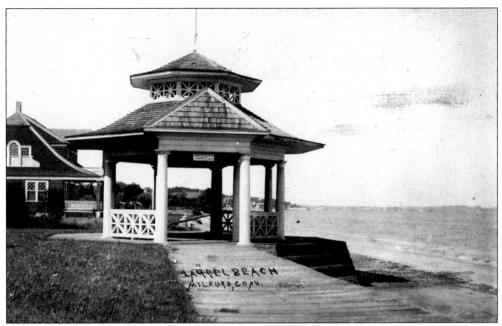

LAUREL BEACH PAGODA. These beautiful structures were built on each end of the boardwalk at Laurel Beach. The view below is from a boat at the pagoda at the east end of the boardwalk, just past the Elsmere Hotel.

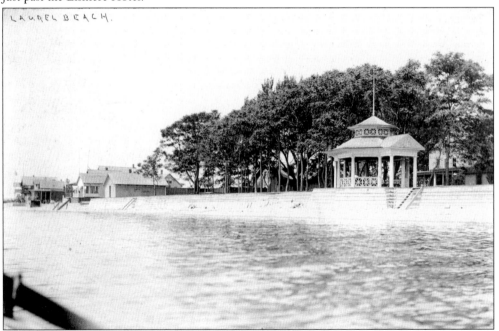

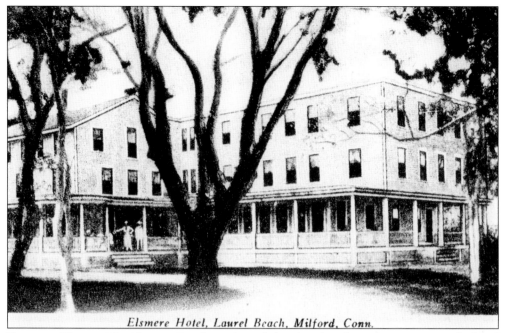

Elsmere Hotel, Laurel Beach, Milford, Conn.

ELSMERE HOTEL. The Elsmere Hotel was the only hotel in this planned community. The hotel had its own private beach and boardwalk. The view below faces east at low tide from the Elsmere boardwalk toward the pagoda that marks the beginning of the Laurel Beach boardwalk.

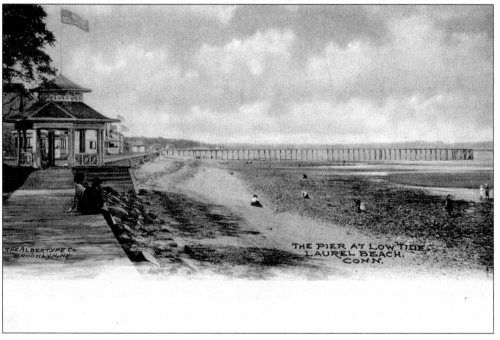

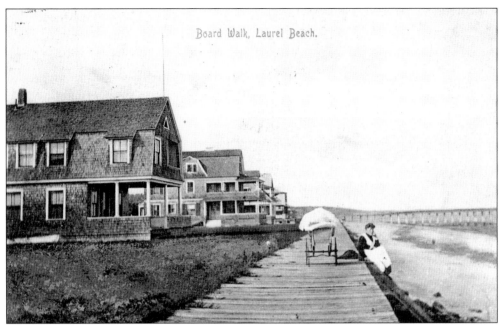

Board Walk, Laurel Beach.

BOARDWALK AND PIER. In the postcard above, a nanny rests on the seawall after taking her charge down to the Laurel Beach boardwalk. The pier is in the distance. A view of the pier looking north on the beach is seen below.

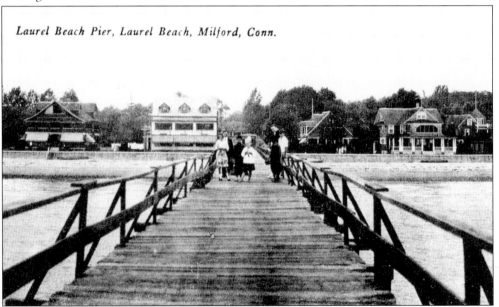

Laurel Beach Pier, Laurel Beach, Milford, Conn.

94

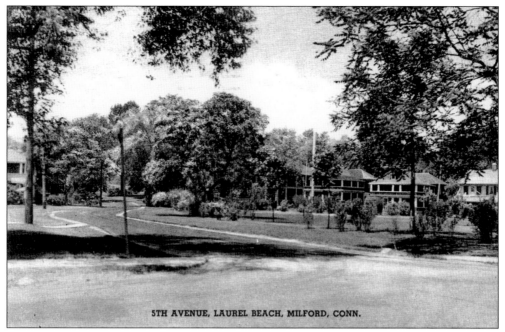

5TH AVENUE, LAUREL BEACH, MILFORD, CONN.

FIFTH AVENUE. The view above displays Fifth Avenue West facing the park toward Fifth Avenue East. There is another view of the Laurel Beach pier below, before houses were built at the waterside.

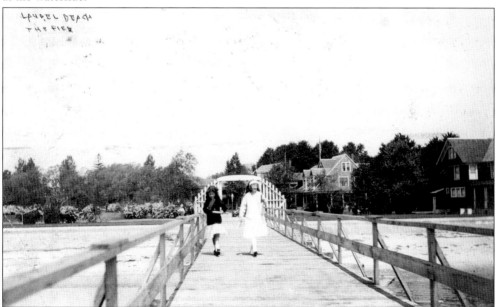

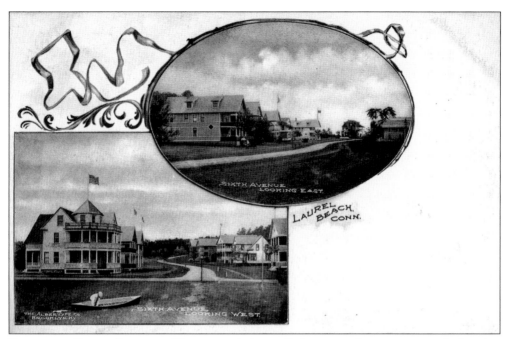

FIRST AND SIXTH STREETS. The postcard above displays two views on one card, showing Sixth Street from the water as it curves into the community. Below one can see a badminton court in a large side yard on First Street, the last street in Laurel Beach.

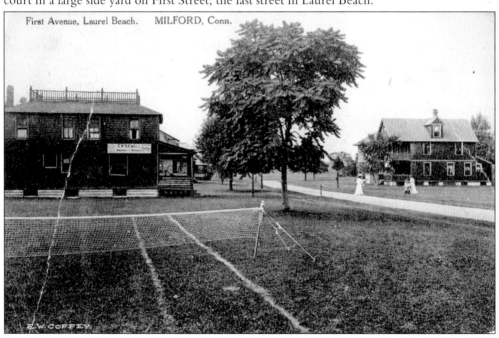

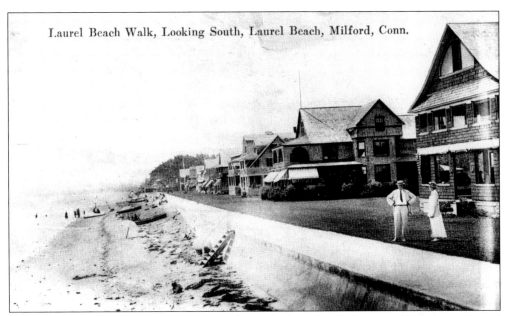

Laurel Beach Walk, Looking South, Laurel Beach, Milford, Conn.

LAUREL BEACH WALK. The image above shows the large family houses with their manicured lawns. With concrete walls and a few feet of elevation, the houses shown below were protected from the problems common to other low-lying Milford beaches.

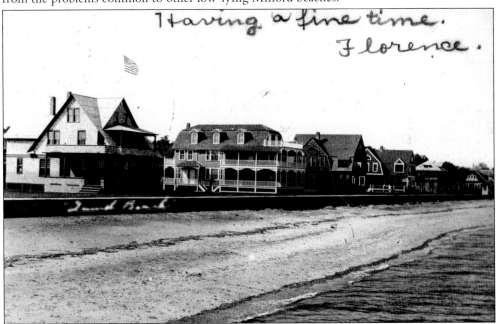

Having a fine time.
Florence.

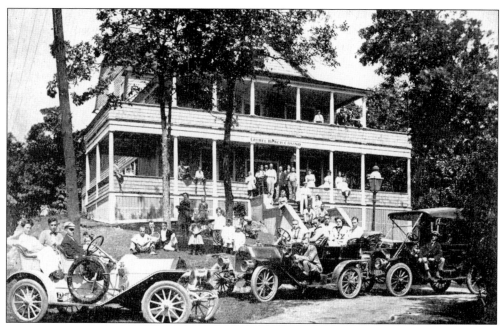

THE CASINO. The Casino shown above was built as the community center for Laurel Beach residents. The scene shown is a Fourth of July gathering. The winter image below shows the high ground the Casino occupies. Tennis courts were also added, and the Casino is still in use today.

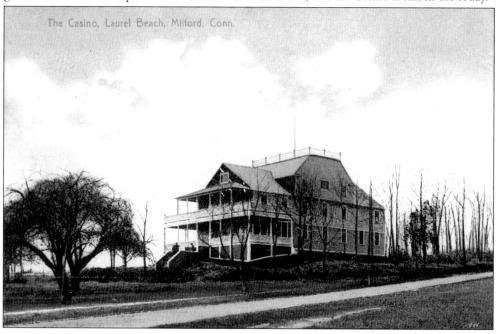

The Casino, Laurel Beach, Milford, Conn.

98

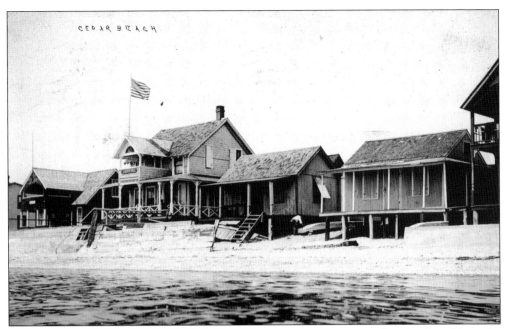

CEDAR BEACH. Seen above and below, Cedar Beach is a narrow strip of sand vulnerable to the ravages of tide and storm. People who built cottages here were truly in touch with nature. The view west seen below shows the cottages built on stilts close to the water.

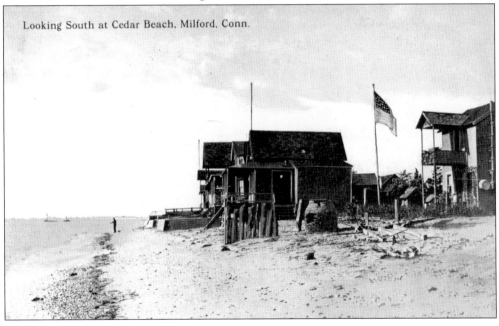

Looking South at Cedar Beach, Milford, Conn.

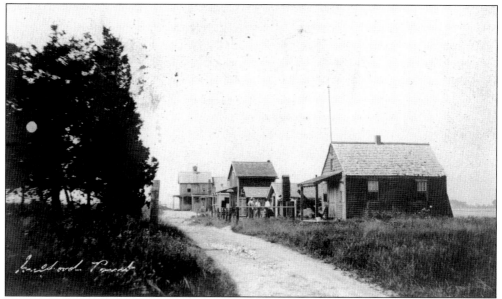

MILFORD POINT. These two views were originally called Smith Point. Milford Point is the easternmost land in Milford at the entrance to the Housatonic River. Surrounded by water and marshes, most of Milford Point it is now a wildlife sanctuary.

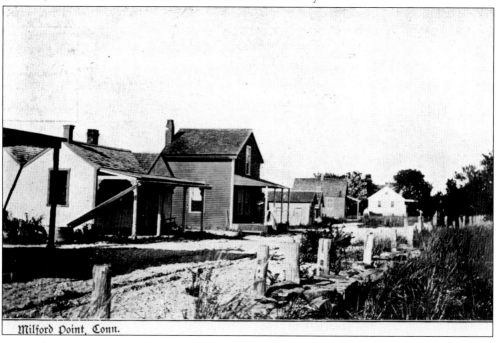

Milford Point, Conn.

Eight

Bay View, Point Beach, and Morningside

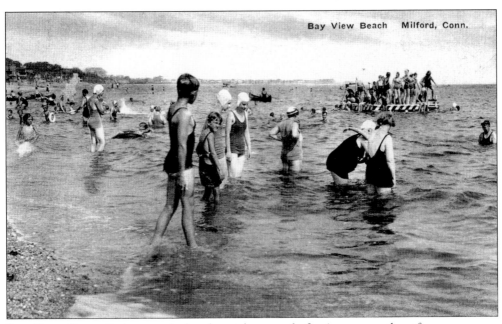

BAY VIEW RAFT. Bathers on the beach watch a crowd of swimmers on the raft.

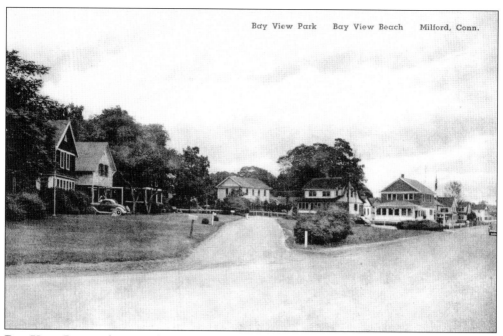

BAY VIEW PARK. This view shows the tiny piece of lawn across the street from Bay View Beach.

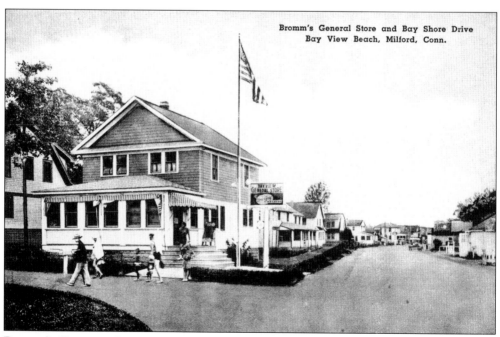

BROOM'S GENERAL STORE. Seen in the postcard above past the park, Broom's supplied bathers with everything they needed for fun at the beach.

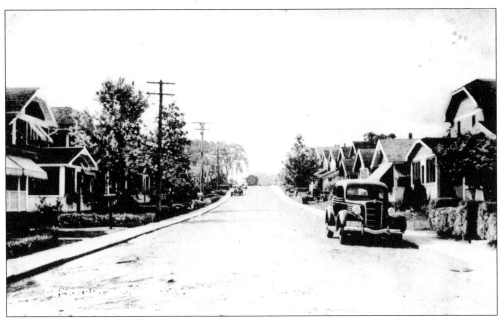

DEERFIELD AVENUE. Looking north up Deerfield Avenue shows the type of cottages that were built after World War I.

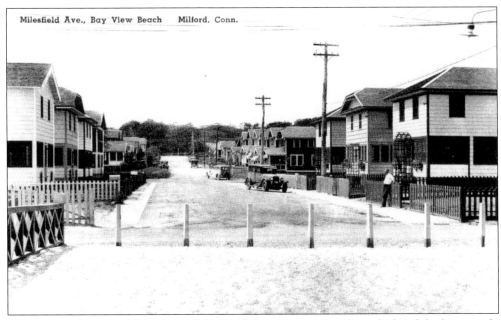

MILESFIELD AVENUE. This view of Milesfield Avenue was taken from the beach looking north.

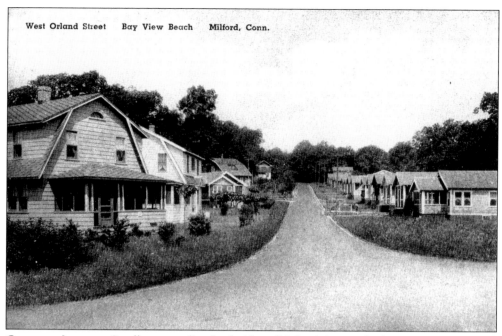

ORLAND AVENUE. Small cottages line both sides of Orland Avenue looking north.

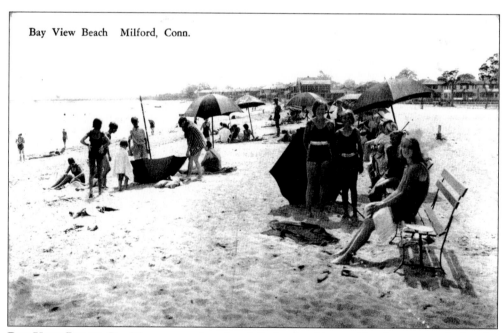

BAY VIEW BEACH. Bay View was a private beach for local residents with a fence across the beach.

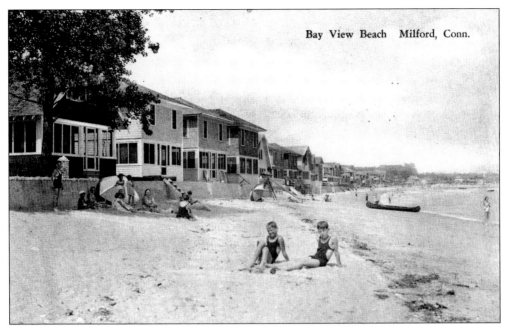

BAY VIEW COTTAGES. This view shows the eastern end of Bay View Beach leading to Pond Point Beach.

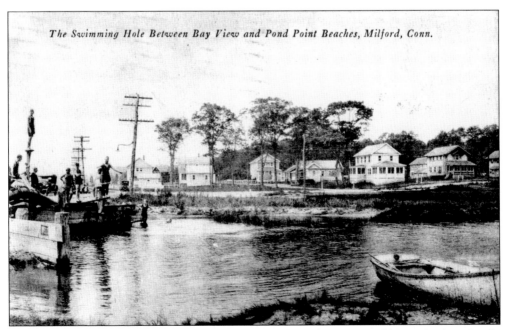

BAY VIEW. The demarcation between Bay View and Pond Point is Calf Pen Meadow Creek, shown here as it empties in Long Island Sound.

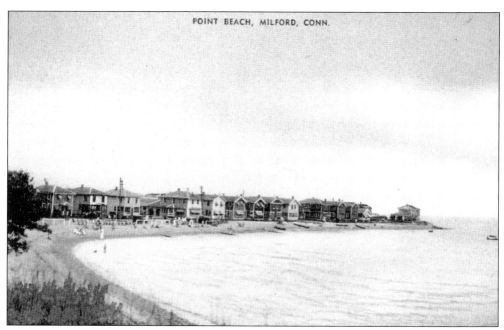

POINT BEACH, MILFORD, CONN.

POND POINT. The long view above shows Point Beach curving to east Pond Point. Cottages along Point Beach face west in the postcard below.

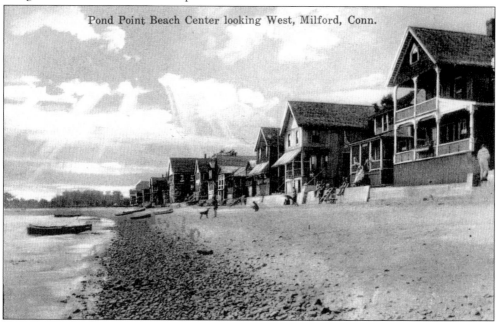

Pond Point Beach Center looking West, Milford, Conn.

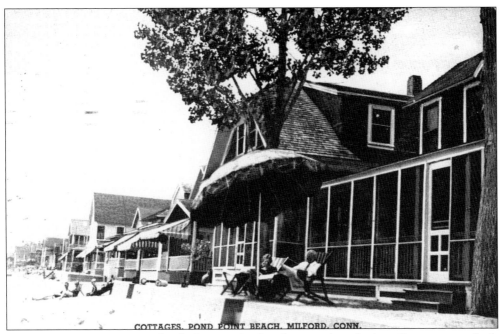

POND POINT COTTAGES. The shade on Point Beach was quite relaxing. Cottages were built directly on the beach before modern codes were passed.

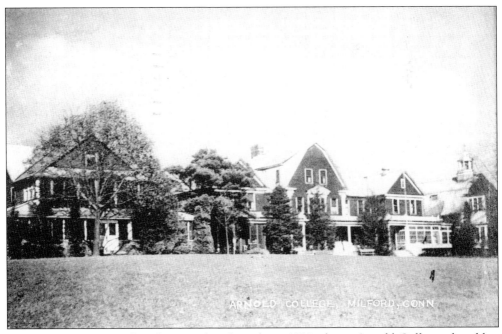

ARNOLD COLLEGE. This photograph, taken about 1930, shows Arnold College, the oldest coeducational school of physical education in the United States. In 1953, it became part of the University of Bridgeport.

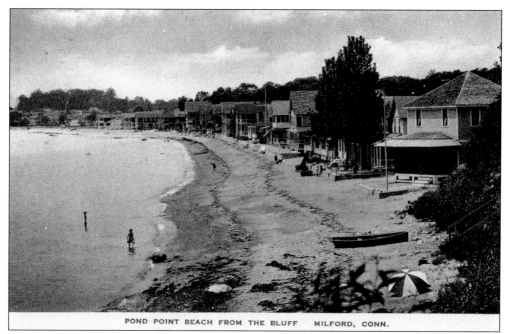

POND POINT BEACH FROM THE BLUFF MILFORD, CONN.

POINT BEACH. Taken from the observatory deck shown below, the view above shows Point Beach. Below there is a view of the bluff and the observatory. Notice the trolley tracks running behind the bluff.

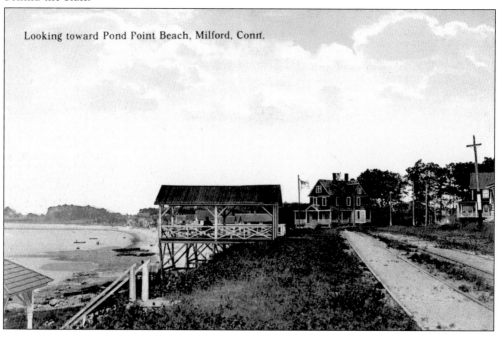

Looking toward Pond Point Beach, Milford, Conn.

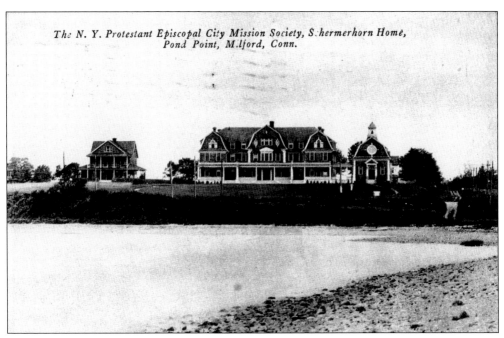

The N. Y. Protestant Episcopal City Mission Society, Schermerhorn Home, Pond Point, Milford, Conn.

SCHEMERHORN HOME. The Schemerhorn Home was built in 1904 as a convalescent home for mothers with children from the slums of New York City. The New York Protestant Episcopal City Mission Society funded this project.

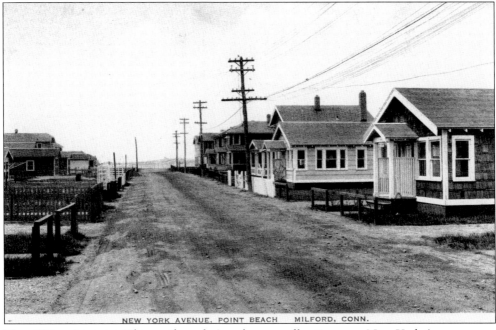

NEW YORK AVENUE, POINT BEACH MILFORD, CONN.

NEW YORK AVENUE. This southward view shows small cottages on New York Avenue.

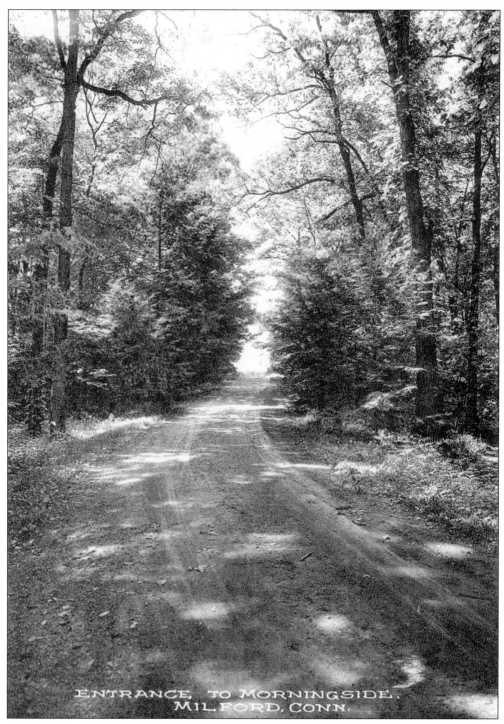

MORNINGSIDE. Seen here is the unpaved entrance to this small community built on the high ground east of Pond Point.

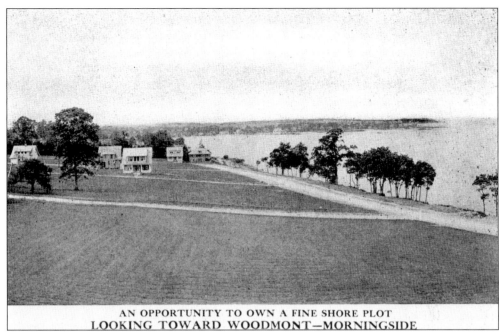

AN OPPORTUNITY TO OWN A FINE SHORE PLOT
LOOKING TOWARD WOODMONT—MORNINGSIDE

VIEWS OF MORNINGSIDE. The top postcard shows advertisements of the shore lots for sale at an undeveloped Morningside. The bottom postcard shows Morningside Drive as it follows the curve along the high bluff before meeting Norwood Avenue at the end of the community.

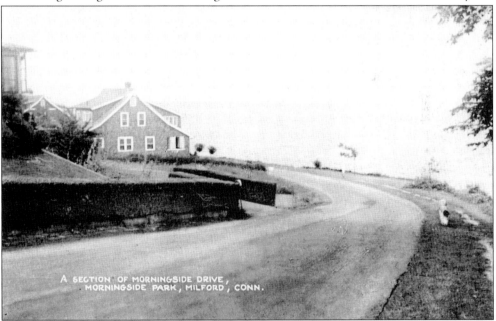

A SECTION OF MORNINGSIDE DRIVE,
MORNINGSIDE PARK, MILFORD, CONN.

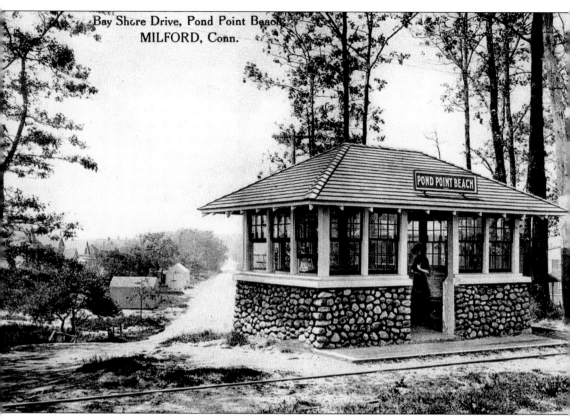

STONE TROLLEY STATION. The stone trolley station on Bay Shore Drive was still used after buses replaced the trolleys.

Nine

THE BOROUGHS
DEVON AND WOODMONT

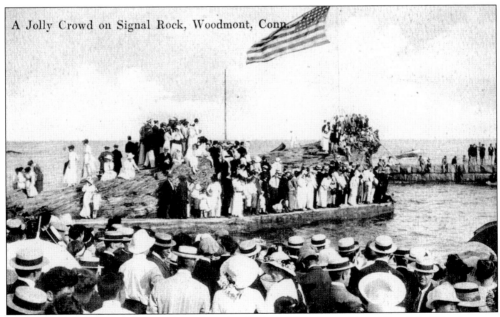

WOODMONT. A crowd gathers for a Fourth of July celebration at Signal Rock in Woodmont.

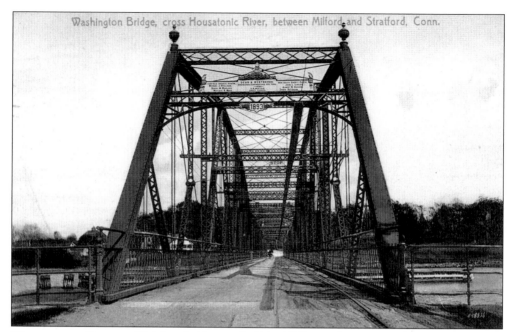

WASHINGTON BRIDGE. This iron bridge was built in 1895 to replace a covered wooden structure, which became a bottleneck for the Boston Post Road, seen below. Completed in 1921, the new Washington Bridge linked Devon with Stratford with a modern roadway.

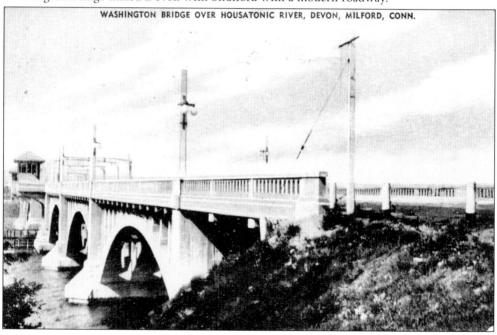

WASHINGTON BRIDGE OVER HOUSATONIC RIVER, DEVON, MILFORD, CONN.

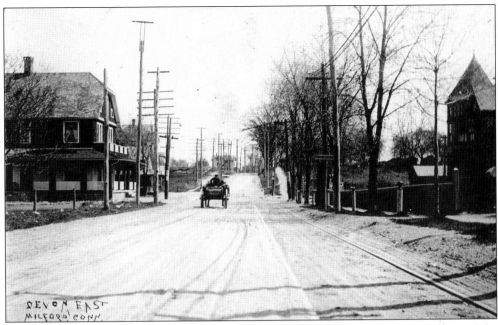

DEVON. Naugatuck Junction was eventually renamed Devon in 1913 after a fire devastated the railroad station and town in 1902. The postcard above looks east on the Boston Post Road, and the postcard below looks west toward the Washington Bridge.

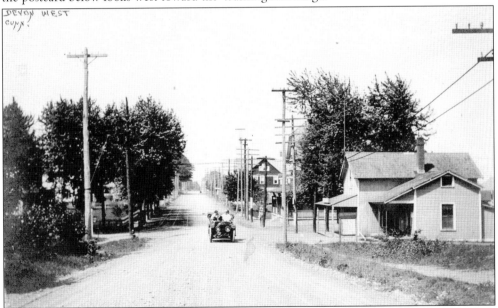

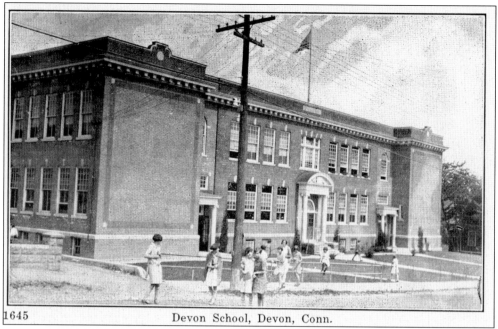

1645 Devon School, Devon, Conn.

LENNOX AVENUE SCHOOL. The Lennox Avenue School, located just off Naugatuck Avenue, was the primary grammar school in Devon until after World War I.

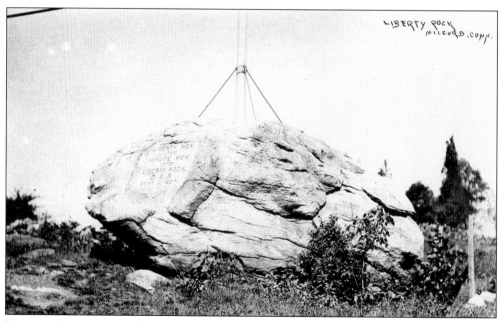

LIBERTY ROCK. Originally called Hog Rock, this 10-foot boulder can be seen from Bridgeport Avenue at the entrance to Devon. Dedicated in 1897, the word "liberty" is carved on the face. The rock was used as a signal station during the Revolutionary War, and it is maintained by the Daughters of the American Revolution.

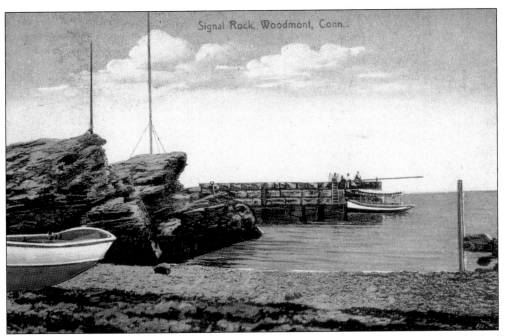

Signal Rock, Woodmont, Conn.

SHORELINE. The two postcards on this page show the rocky shoreline at the west end of Woodmont. Signal Rock is pictured in the top postcard, while Woodmont Point and beach are featured in the bottom postcard.

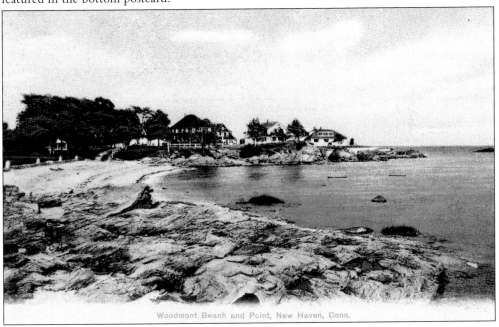

Woodmont Beach and Point, New Haven, Conn.

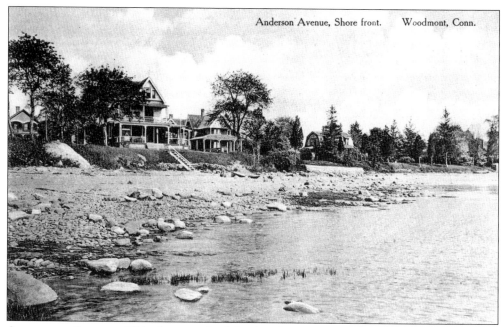

Anderson Avenue, Shore front. Woodmont, Conn.

ANDERSON AVENUE. This photograph of the shoreline at low tide shows the large residences in Woodmont Beach.

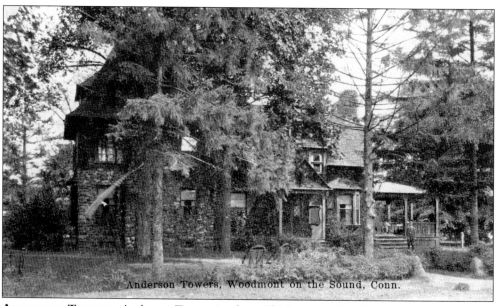

Anderson Towers, Woodmont on the Sound, Conn.

ANDERSON TOWERS. Anderson Towers is a beautiful house built of fieldstones.

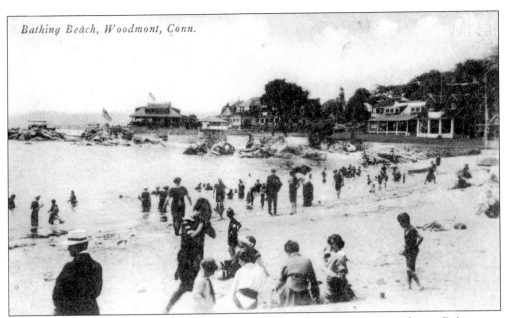

Bathing Beach, Woodmont, Conn.

WOODMONT BEACH. This postcard shows the bathing beach just past Woodmont Point.

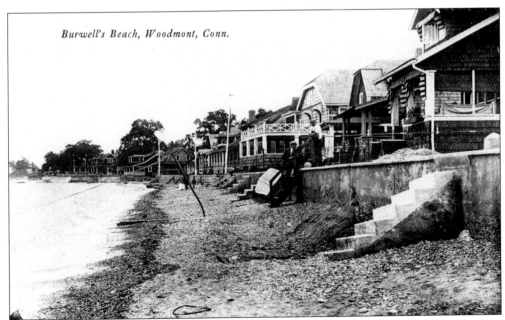

Burwell's Beach, Woodmont, Conn.

BURWELL'S BEACH. This area of Woodmont is named for the Burwell family, who operated a large farm dating back to the founding of Milford.

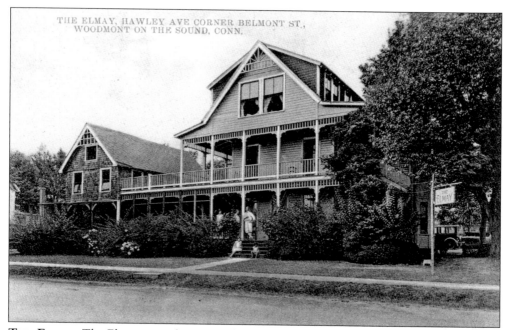

THE ELMAY. The Elmay was a large guesthouse located one block from Woodmont Beach at the corner of Hawley Avenue and Belmont Street.

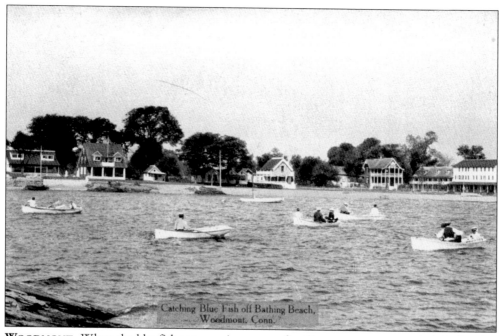

WOODMONT. When the bluefish are running, many families come out to try their luck. This is still true today.

PECK'S SANATORIUM. It is difficult to imagine a better place to recuperate from an illness than Peck's Sanatorium. Woodmont offered quiet streets and little traffic.

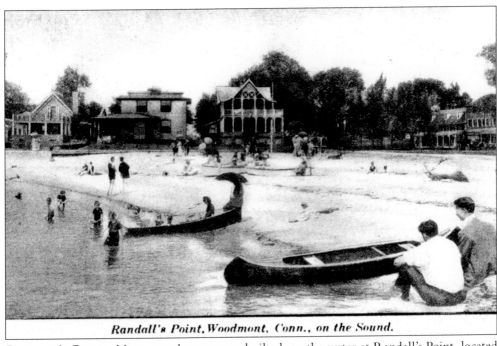

Randall's Point, Woodmont, Conn., on the Sound.

RANDALL'S POINT. Many guesthouses were built along the water at Randall's Point, located at the widest beach in Woodmont.

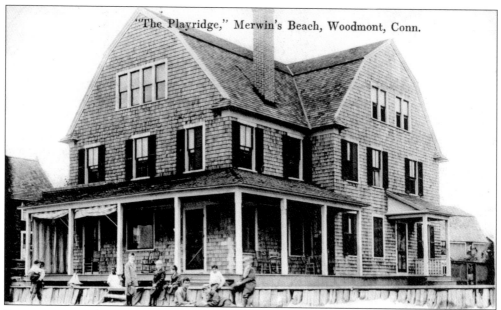

PLAYRIDGE. Built on the beach, the Playridge was a family-style guesthouse.

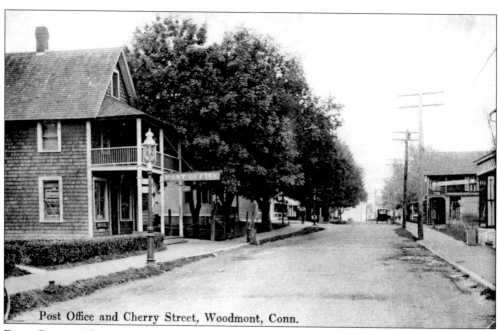

POST OFFICE. The post office that served all of Woodmont was located on Cherry Street before Word War I.

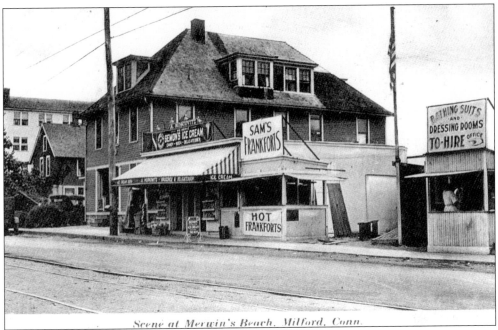

Scene at Merwin's Beach, Milford, Conn.

MOSCOVITZ DELICATESSION. New Yorkers flocked to this area of Woodmont, making Moscovitz's a popular store. Seen to the right of this photograph is a woman who rents bathing suits in a small stand.

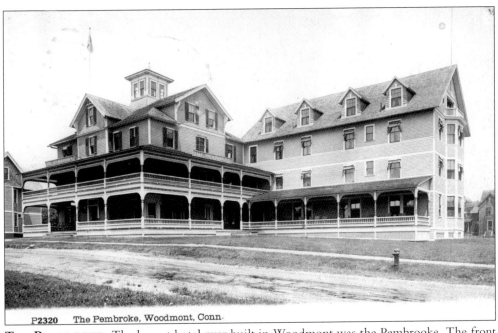

P2320 The Pembroke, Woodmont, Conn.

THE PEMBROOKE. The largest hotel ever built in Woodmont was the Pembrooke. The front section of the building was used as a restaurant.

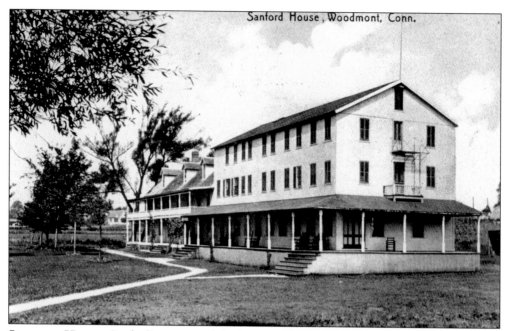

SANFORD HOUSE. Sanford's was one of the largest guest hotels built in Woodmont. It was well known for its seafood dinners.

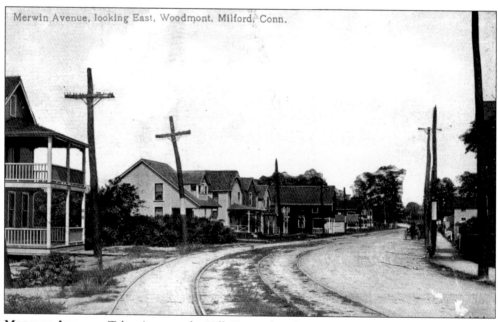

MERWIN AVENUE. Taken just past the Villa Rosa, this photograph shows the trolley tracks that run down the unpaved street.

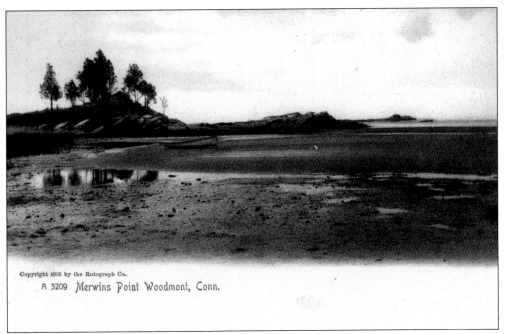

A 3209 Merwins Point Woodmont, Conn.

MERWIN'S POINT. This is a view of Merwin's Point at low tide. It looks as though someone could walk all the way out.

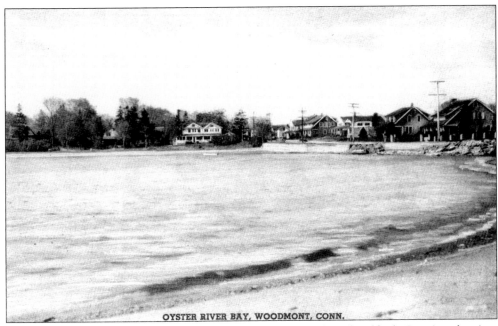

OYSTER RIVER BAY, WOODMONT, CONN.

OYSTER RIVER. The Oyster River is the easternmost border of Milford. Crossing the river from Woodmont takes one to West Haven.

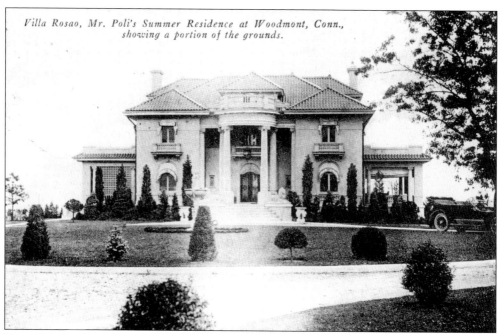

Villa Rosao, Mr. Poli's Summer Residence at Woodmont, Conn., showing a portion of the grounds.

VILLA ROSA. The Poli family owned the largest chain of movie theaters in New Haven and, later, New York after a merge with the Lowe's chain. In Woodmont, Sylvester Poli built a mansion and houses for each of his family members.

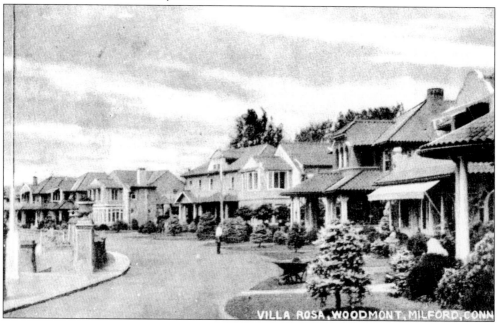

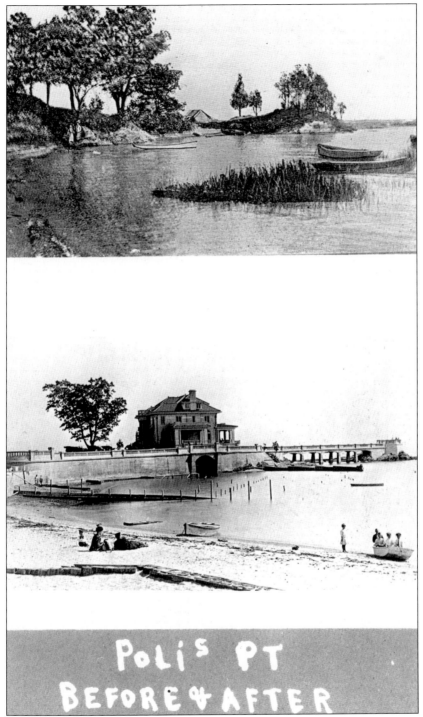

POLI'S POINT. This postcard shows the before and after effects of when Sylvester Poli built a boathouse and protected beach area for his family.

BIBLIOGRAPHY

Federal Writers' Project of the Work Projects Administration for the State of Connecticut. *History of Milford, Connecticut*. Bridgeport, CT: Braunworth and Company, 1939.

Smith, DeForest. *Only in Milford: An Illustrated History*. Milford, CT: George J. Smith and Son Realtors, 1989.

Tercentenary Commission of the State of Connecticut. *The Early Development of a Town as Shown in Its Land Records*. New Haven, CT: Yale University Press, 1933.

Walnut Beach–Myrtle Beach Historical Association. *Sand in Our Shoes*. Milford, CT: 2004.